GREAT ARTISTS COLLECTION

Five centuries of great art in full colour

JAPANESE COLOUR PRINTS

by J. HILLIER

ENCYCLOPAEDIA BRITANNICA : LONDON

Volume seven

COVER: Detail from *Moonlight, Nagakubo* by Hiroshige
(*Plate 45*)

All rights reserved by Phaidon Press Limited, London

*This revised edition published in 1972
by Encyclopaedia Britannica International Limited, London*

ISBN 0 85229 107 8

Printed in Great Britain

JAPANESE COLOUR PRINTS

FOR us in this country, the opportunities of an acquaintance with Japanese art are few. Although there are galleries in practically every large town where the works of European schools can be studied, there is no permanent exhibition of Japanese painting anywhere, and in any case, though the British Museum has a fairly representative collection that can be studied on application, most of the finest examples of Japanese painting remain in Japan. It is not surprising, therefore, that when, on rare occasions, a Japanese picture, or a reproduction of one, is seen, it impinges itself on most people as something unintelligible, remote from our own art, portraying in a strange stylistic manner a world where custom and dress, legend and history, and even the physiognomy of the inhabitants, are unfamiliar.

Yet to those who study the art of Japan, this foreignness of style and subject soon ceases to be an obstacle to appreciation. Indeed, though the subject matter may remain uninterpreted, the style is found to be an exposition of the highest ideals of the art of painting, vying in its own idiom with the greatest painting of Italy and France, and anticipating by hundreds of years, and enjoying by right, the freedom from the 'tyranny of nature' so hardly won by modern European artists since Cézanne.

Though the actual paintings of Japan are so far out of reach, the colour-prints of the country are fortunately more accessible; the British Museum and the Victoria and Albert Museum, the Museum of Fine Arts in Boston, the Art Institute of Chicago, the Wadsworth Atheneum in Hartford and the New York Public Library contain many fine prints, and many still pass through the hands of art-dealers and auctioneers. It is true that these prints are the product of a relatively humble school that came late into being in the seventeenth century, and whose finest works in no sense realize the highest aims of Japanese art: but for us they provide a gateway, an easy initiation into an art that to many may seem forbidding, not only from its foreignness, but from the austerity of its lofty conceptions. There are those who may eventually scale those ultimate peaks, but others will rest content with the pleasures of the lower slopes.

But even these prints, woodcuts printed in colours and bought by the masses, at once delightful to our eyes and needing little adjustment of our normal focus for them to yield real aesthetic pleasure, even these have for long been known only to the minority. Literature on the subject has generally been intended more for collectors than for the general art-lover and has assumed as a rule far more advanced a knowledge of Oriental art than the average reader, for the reasons given, has been able to acquire. Moreover, except in the most expensive editions, books on the colour-print have been illustrated very inadequately.

In this book, the aim has been to present the colour-print as an art, rooted in the principles of Japanese painting but needing for its appreciation no deep knowledge of those principles, examples being selected for reproduction not so much for their rarity as their power to bring home the unique qualities of Japanese art and especially of the colour-print art. Similarly, the text deals with the subject in general terms, sketching the character of the people for whom the prints were brought into being; the development of the artists' style; and some of the causes for its distinctiveness from all we are used to in European art.

THE PICTORIAL ART OF JAPAN

THE colour-print was in the main, though not exclusively, the product of a certain school of painters that arose in the seventeenth century, whose methods were considered sufficiently different from those of the established schools to earn a name of its own, the *Ukiyo-e*, or 'Pictures of the Fleeting World' School. But although that title, with its hint of opprobrium, suggesting as it does a concern with the petty things of everyday life in contrast to the 'eternal verities' that engaged followers of older schools, distinguishes a quite clearly separate style of Japanese painting, that style is still essentially Japanese, and an explanation of certain of the characteristics of the colour-print best begins in a general consideration of the art of painting as practised in Japan. A comparison, at the same time, with Western art, gives an opportunity to deal with some of the objections to Japanese art which are almost inevitably raised by those steeped in the Western traditions who approach it for the first time. Perhaps 'comparison' is hardly an accurate term where such incompatibles are concerned, for though identical in that both are pictorial means of expression, the gulf between them is deeper than the Pacific.

Japanese painting is more limited in range than European: but more perfect within its proscribed limits. Its limitations were due in part to the restricted media and opportunities open to the Japanese compared with those available to the Western artists, to whom the advent of oil-painting gave possibilities of expression never accepted by the Japanese, or, as some would say, wisely eschewed by them. It is true that modern Japanese artists have used oils, but in doing so they have adopted European methods, and in any consideration of the art of their country one refers to the products of the purely native schools, Kano, Tosa, Korin, Shijo—a Japanese, painting in a Western style, loses his national identity as completely as his countryman who forsakes the *kimono* for the lounge suit.

Oddly enough, the choice of media was imposed on the Japanese as much by geological and climatic factors as by any innate artistic preference or instinct: the flimsy construction of their buildings, dictated by the recurrence of earthquakes and leading to frequent conflagrations, precluded anything like the great wall spaces enjoyed by the early European painters in fresco and tempera, or even the solid frame and robust canvas normal to our oil painters. Instead, they used water-colours on silk and paper, materials which, in the characteristic *makimono* and *kakemono* forms (the first a long horizontal, the other a tall vertical, oblong), could be rolled up and moved to a place of safety, where for the most part of the year they were stored.

The use of water-colour, and later of wood-cuts printed in colours, tended to stand in the way, if there had been any movement in that direction, of any laborious technique which might have led, as the oil-painting technique did in Europe, to the mimicry of visual appearances. But water-colour *could* have been turned to this copy-work—after all, Birket Foster used identical materials; but from the first, the Japanese genius was for the expressive line, for pattern and design, the representation of natural objects as a means to an end, not an end in itself. Chiaroscuro and linear perspective, used by Western artists to give the verisimilitude of solidity in natural

objects and their recession in space, were ignored, though not unknown. Normally they did not 'draw from nature' as we are, or were, taught to, but stored images in the mind until the mood was upon them to paint: with them, painting, like poetry, was the 'spontaneous overflow of powerful feelings' and took its origin from 'emotion recollected in tranquillity'.

Fundamentally, the difference between Japanese and Western art lies not so much in media or technique as in the aim of the artists, the conception of the function of painting. With us, until comparatively modern times, the art of painting was tied to some underlying purpose of decoration, story-telling, portrayal of people or chronicling of events. Progress was measured by the closer and still closer approximation to the appearances of things, Ruskin typifying that form of art criticism that uses 'truth to nature' as the yardstick to measure a painter's stature. True, since Ruskin and the invention of photography, there has been a growing realization that the art of painting should reside in something more than the simple aim of imitation (contact with the art of the East from the nineteenth century onwards almost certainly speeded that realization), but until then, European painting was descriptive or objective, often the dependant of the sister art of architecture, often fulfilling the function that a camera fulfils today. The paintings of El Greco and William Blake, to name two at least who are exceptions to the rule, have qualities which even now do not find general acceptance among us.

The work of the Japanese painter, unhampered by the external considerations that pressed upon the European, was valued for the 'beauty and significance of touch', the actual brush-strokes, the arabesque of their line, having, for people who appraised calligraphy as one of the fine arts, an appeal that we learn but slowly to appreciate; and conveyed, to the well-stocked mind, not directly but by hints and allusions, a whole world of meaning lost upon us. There is nothing in their art akin to the portraiture of Reynolds, still less of Rembrandt or Velazquez; no landscapes of the fidelity to topography and atmosphere that Constable, Turner or Monet achieved; little of the allegorical, narrative or didactic painting, the 'sermons in paint' which, on wall and canvas, from Giotto to Brangwyn, have been accepted as one of the functions of the art in the West. Theirs was an art in which line and hue and *notan* were evocative in the way that a word, or a turn of phrase, is evocative in our poetry. Laurence Binyon, referring to the classic Kano school, wrote: 'The one thing necessary for a work of art was that it should bring with it the fertilising seed to come to flower in the beholder's mind: the thought of the artist was to enter like a guest into a room made ready for his welcome.'

THE ORIGIN OF THE COLOUR-PRINT

It can readily be imagined that even among the Japanese such an art could only be addressed to those of a culture comparable to that of the artists, and in fact its appreciation was restricted to the aristocratic minority of the nation. The art of Ukiyo-e, of the colour-print artists, was, on the other hand, the art of a popular school, and for that reason if for no other, the colour-prints are more readily enjoyed by us than the works of the earlier masters: indeed, though their allegiance is decidedly to the East, they seem to occupy a sort of border state between East and West, with an artistic climate more nearly approaching our own, and whence we can approach

by an easy gradient to the more difficult peaks, the rarefied atmosphere, of the ancient classical art.

The advent of such a popular art was bound up with great social changes, and was dependent on the emergence of a class of people that had no previous counterpart. After generations of internecine struggles, the firm rule of the Tokugawa Shogunate, first installed to power at the beginning of the seventeenth century, brought stability and prosperity to the troubled country, and the population of the new capital, Edo, grew rapidly. Education was more widely disseminated than ever before, and a middle class of tradesmen, artisans and merchants emerged, quick-witted, intelligent, pleasure-loving and avid for novelty. It was for this parvenu class that the *Kabuki*, or Popular Drama, the Marionette Theatre, and an immensely varied and voluminous literature came into being, and it was to illustrate the publications of the day that the first Ukiyo-e woodcuts were made. Before considering the gradual development of the colour-print from these first beginnings, it is well to go a little deeper into a question of paramount importance in Japanese art—Style.

THE UKIYO-E STYLE

Consistent with the acceptance of painting as an art in its own right, styles of painting in Japan are differentiated more on the grounds of brushwork than on the type of subject-matter. The Ukiyo-e style is primarily a style of *painting*, which emerged with a clearly separate identity in the seventeenth century, but whose origins were complex and traceable to a number of different artists of the late sixteenth and early seventeenth centuries, all of whom showed an unusual interest in the passing scene, in the fashionable clothes and vices, and who were seeking, tentatively at that stage, a pictorial language adequate to convey their worldly outlook. These early artists expressed themselves in paintings only—the Ukiyo-e woodcut did not arrive until the second half of the seventeenth century. In the make-up of their style are elements borrowed from both the Tosa and the Kano schools, the vivid opaque colour of the one, the strong forceful bounding line of the other, and moreover, the class of subject depicted, something approaching a Japanese genre, had only occasionally appeared before, especially in the Yamato-e scrolls, the narrative paintings of the first truly native artists, active from the tenth to the thirteenth centuries.

But the paintings, executed for comparatively wealthy patrons, were limited in number and in circulation. The style was first directed to a wider audience by some anonymous book-illustrators of the mid-seventeenth century, and soon after, Moronobu, in prolific illustrations to books and later in separately issued broadsheets, imposed a style in drawing for the woodcut and a range of subject matter that proved the greatest single influence on the subsequent history of the colour-print.

In a selection of prints such as those reproduced here, one of the most striking features is the oneness of the style that, for all the developments in technique and the following of changing fashions in dress and manners, informs the work of artists of widely separated periods. The exceptions are to be found in the essays in the Kano or Chinese styles that occasionally occur; in the flirting with European methods in such prints as the 'perspective pictures' known as *Uki-e*; and in some phases of the work of Hokusai, whose eclecticism, his assimilation of the

styles of a variety of schools, renders some of his prints barely classifiable as Ukiyo-e, notwithstanding the colour-print medium.

Without a comparison, not possible, here, with the other various styles of Japanese painting, it is rather difficult to bring home the characteristics that single out a Ukiyo-e drawing from that in any other style: but suffice to say that there is an immediately obvious kinship, notwithstanding the differences already noted, between the drawings of a woman by such diversely gifted artists as Moronobu, Kaigetsudo, Okumura Masanobu, Harunobu or Kiyonaga, and an equally clear distinction between their drawings and those of a Kano or Tosa master. Although the Ukiyo-e style was based on both the Kano and the Tosa, its suave flowing lines are never mistakable for the impetuous, splintery strokes of the Kano masters, and the lively near-naturalism of its figure-painting is a world apart from the stiff, ritualistic manner of the Tosa.

This continuity of a style through generation after generation of artists was the result of the method of training. A pupil accepted by one of the masters was like the apprentice to any other craftsman: he followed implicitly the instructions of the master, reproduced his productions as closely as possible. We in the West, at any rate since mediaeval times, have no parallel to the rule and authority exercised by the Japanese painter over his pupil: not only had the main tenets of the school of adoption to be respected, but the particular idiosyncrasies of the sub-school in which the young artist had enrolled had to be followed with complete fidelity. Hence the great similarity —the impossibility of telling apart, quite often—of the prints, say, of Harunobu and his pupils (one named Harushige openly confessed to forging Harunobu's signature, and no two experts have ever agreed as to which are the forgeries); of Shunsho and those of his pupils who produced theatrical prints; of Kiyonaga and all those that fell under his sway, such as Shuncho and Eishi.

Without knowing the prints, it might be inferred that such a system could only lead to servile copying and stagnation, but, in fact, the reverse was the case. Each great artist, and there was a constant succession of them, beginning as an imitator of his master, developed an individuality in drawing and treatment of subject that stamp his prints as plainly as the signature or seal upon them: and that he, in his turn, was successfully imitated by his successors only emphasizes his distinctive achievement as an innovator.

In perhaps no other aspect can this be made clearer than in the drawing of women, to whom, above all, the Ukiyo-e artists devoted their work. The small, compactly-drawn figures of Moronobu are given imposing build and monumental poise in the massive lines of Kaigetsudo and Kiyonobu; Okumura Masanobu and Sukenobu infuse a new sweetness, a graciousness of mien and movement absent before; Harunobu reduces them to captivating child-women, of flower-like fragility, but Koryusai, Shigemasa and Kitao Masanobu gradually, with an increase in naturalism, give the figures nobler lines again, culminating in the queenly, Junoesque forms that Kiyonaga drew; while with Eishi, Choki and Utamaro, yet new, disturbing characteristics appear, the allure of languor and sophistication. The power to rise above the stereotyping that the Japanese system of tutelage tended to enforce is the mark of the great artist.

A criticism often levelled at the Japanese print, or at Japanese painting generally for that matter, is that there is no characterization in the features, that all the faces look alike. Superficially, there is some truth in this; and the cause brings me back to my starting point, the distinction between Oriental and Occidental art. There was no *prima facie* obligation in the Japanese conception of

painting to reproduce visual appearances: natural forms, of which the human head is one, were introduced into a picture with only as much realism as was compatible with the painter's objective: and so, the face, as an element in the design, received no more, and no less, attention than the other components in that design. Singling out the face for detailed treatment would have unbalanced the composition: in fact, their art, relying primarily on line without the Western device of chiaroscuro, tended to become caricatural when portraiture was attempted, as Sharaku's prints, with their greater realism, tend to prove.

But within these limits, there are evident differences between each great artist's depiction of the head: each had his own ideal, his work can be identified by his predilection for a certain facial type, as a study of the reproductions will show. For instance, however close in other respects the drawings of Harunobu, Buncho and Shunsho may have been at one period, there is no mistaking the small-featured demure face of Harunobu's *musume* for the aquiline, more experienced face of Buncho's, or the rounder, placid countenance favoured by Shunsho for either. Utamaro went even further, and proclaimed himself on a certain famous series of prints the 'Physiognomist', and although even these heads are far from satisfying our own ideas of portraiture, there is evident characterization of recognizable types: types, be it noted, rather than individuals: the general rather than the particular.

THE TECHNIQUE OF THE COLOUR-PRINT

The success of the illustrated book, and the demand by the common people for pictures that could be displayed, as in the upper-class houses, in the *tokonoma*, a quiet corner of a room where a picture could be contemplated with undisturbed serenity, led to the production of separate broadsheets, *ichimai-e*, of larger size than the normal illustrated book. These broadsheets were at first in black outline only, but within a very short time, the need to imitate paintings more closely led to the application of colour by hand, and so the earliest Japanese print—not a true 'colour-print' at this stage—is in outline only, or roughly touched in with strong colours that match the forceful lines of the woodcut.

There is nothing more impressive in the whole range of Japanese art than the large prints of the great masters of this period, Moronobu, Kaigetsudo, Sugimura, the first Kiyonobu, Kiyomasu and the young Okumura Masanobu. In their depictions of courtesan and paramour, actor and theatre-goer, there is the swing of an undulating line, a rhythmic flow in design and a boldness of contour admirably fitted to the woodcut line.

An additional refinement introduced during this period was the application of lustrous black and of brass and other metal dusts over a gum base in imitation of lacquer-work with applied gold. Known from this as 'lacquer-prints', *urishi-e*, this kind of print is often of a barbaric splendour in its sombre colour and glinting brass-dust, and some supremely beautiful examples were designed by Kiyomasu, Okumura Masanobu and his pupil Toshinobu, and by Shigenaga.

The outline and hand-coloured prints prevailed for several decades, and it was not until about 1740 that colours as well as the outlines were printed from wood blocks, and even then, for another twenty years or so, the colours so applied were limited to two, usually a light red and a green.

With the coming of the two-colour-prints came a change in the designs, a tendency to smaller size, to slenderer figures, less robust decorative motifs: a change due, it seems likely, to the artists' unerring sense of balance, the feeling that the rose and green would be garish if applied to prints on the scale of the outline-prints that had hitherto prevailed.

Okumura Masanobu, one of the greatest of the 'primitives' and responsible for a number of innovations, is again one of the outstanding figures where the two-coloured prints (*beni-e*) are concerned, but by this time numerous artists of merit were working in the Ukiyo-e style, notably the second Kiyonobu; Kiyohiro, and Kiyomitsu; Shigenaga and Toyonobu. With these artists one notices a gradual introduction of fresh motives for the broadsheets, idyllic scenes in which exquisitely clothed figures move gracefully against a lightly-indicated background, the curve of a river, the cone of Fuji beyond the ricefields, the corner of a tea-house with a bamboo beside it.

This idyllic, consciously poetic element became all-pervading in the work of Ukiyo-e artists, and was miraculously enhanced by the introduction in 1764, traditionally by Harunobu, of the full polychrome print, the true *nishiki-e*, or brocade-print, as it was called. The accession of new technical resources, the incentive given by a public gradually more cultured and discerning, brought an immense response from the artists, and from Harunobu onwards (his great output in full colour was limited to the six years between 1764 and his death in 1770), there was a succession of artists of first rank: Koryusai; Shigemasa and his pupils Kitao Masanobu and Masayoshi; Shunsho and his pupils Shunko and Shunei; Toyoharu; Kiyonaga and his followers, Shuncho, Shunzan and Shunman; Eishi and his pupils Eisho, Eisui and Eiri; Utamaro; Choki; Sharaku; Hokusai and his pupils Hokkei and Gakutei; Toyohiro; Toyokuni and his pupils Kunimasa, Kuniyoshi and Kunisada; Hiroshige; Eisen. This makes a formidable list of names, but some conception of the wealth of talent exerting itself in the field of the colour-print is obtained if it is realized that even this long list could be doubled by including names of other pupils and independent artists whose work, if rarer, is often of very high quality.

The colour-print was the result of the collaboration of four distinct people: the publisher, who commissioned the work and co-ordinated the operations of the other three concerned in its production, and whose importance, consequently, cannot be over-rated—many of the finest prints are due to the enterprise and discernment of publishers like Tsutaya Jusaburo and Eijudo; the designer, with whom this book is most intimately concerned; the engraver; and the printer. To these, some would add a fifth, quite logically—the paper-maker: the superb texture and surface of the hand-made, mulberry-bark papers do much to enhance the bloom and soft radiance of the colours.

The woodcut medium came naturally to the Ukiyo-e artists. There was already in existence a body of facsimile wood-engravers, long trained in the cutting of brush-drawn characters for the texts of books. To such engravers, the cutting of an outline block from a brush drawing supplied by the artist was a comparatively simple matter, and an extremely high standard of fidelity was normal. It is a matter of surprise that the application of colour by wood-blocks was so long deferred, for Chinese colour-prints of the seventeenth century, employing a wide range of colours, must have been known in Edo. No doubt the need to keep the price within the reach of the humble Edo folk was one of the factors responsible.

A great deal depended on the craftsmen responsible for block-cutting and printing. The artist merely supplied the drawing on transparent paper and indicated the colours by painting them in on a 'pull' from the 'key-block', as the outline print was known. The engraver, pasting the drawing face-down on a block of hard wood like cherry (not on the 'end-grain' as has been customary in the West since Bewick's day, but on the 'plank' in the manner of Dürer's engravers), cut around the lines with a knife, and by clearing the wood between the lines, left them in high relief. The ink having been rubbed on to the raised lines, proofing paper was placed over the block, pressure was applied by rubbing a twist of hemp over the back of the paper, and a proof of the engraver's facsimile of the artist's design thus secured.

Usually, the artist's original drawing was cut to pieces by the engraver in preparing the key-block, but a number of brush drawings for prints exist which seem to suggest that in some cases the engraving was made from a copy of the original design.

After the artist had indicated the colours on a proof of the key-block, a separate block had to be cut for each colour that was to be printed, and in a print of complex tints, as many as ten or more such additional blocks might be required, from which, with over-printings, a remarkable range of colour was obtainable. The colours were mixed by the printer on each block separately, a little size made from rice being added to give a firm consistency. Accuracy of register, of first importance as a print passed from one block to another to receive its succession of colours, was secured by a guide mark for the proofer, consisting of a right-angle cut at one corner of each block and a straight line at an adjoining side, aligned with one side of the right-angle.

Until the nineteenth century, the colours were mainly of vegetable origin, and, unfortunately, fugitive on exposure to light, the sky-blue, violet and pink fading to buffs and greys still beautiful in themselves, but something quite different from the bright hues that originally caught the eye of the Edo purchaser. With the singular perversity of their race, some collectors have affected to admire the time-faded print in preference to another in its original colours, but although many fade in harmony, the quiet, subdued tones of such prints are those of preserved flowers, lacking the gaiety and liveliness of the living thing. Besides, quite often the precious harmony of colour achieved by some artists, Harunobu in particular, is destroyed when more stable greens, yellows and a chocolate brown remain unimpaired whilst other shades have become uniformly dulled. To collectors of the kind mentioned, the print in its original state comes as much of a shock as cleaned pictures, seen at last in all their bright colour, come to lovers of the 'embrowned' tones of the Old Masters.

Among the various embellishing devices used by the printer are the use of mica in backgrounds, or for picking out mirrors and frosty or icy surfaces; the application of metal-dusts, either sprinkled or applied by block; and *gauffrage*, or blind-printing, for indicating the patterns and folds of dresses, the plumage of birds or the fur of animals, by lines in relief but without colour.

There seems to be no certainty as to the number of prints taken from one set of blocks, but an extant letter of Hokusai's to one of his publishers set the limit at 200 prints. After long use, a saturated block ceases to take colour evenly and the fine lines begin to wear down, but modern block-makers concerned with producing facsimiles of old prints, take many more proofs than 200 from a block, and one publisher has expressed the view that a thousand or more can be taken before the block deteriorates.

From a variety of causes, the sizes and shapes of the prints were constantly changing, but only the formats peculiar to the Japanese print need be mentioned. As a substitute for paintings, it was natural that quite early the *kakemono-e* should have been introduced, since this most nearly resembled the hanging painting, and it was, in fact, often mounted like a painting on rollers. The diptych, triptych and other multi-sheet prints seem to have had their origin in the practice, prevalent among painters of the established schools, of producing two or three separate paintings that were linked partly by similarity of subject, partly by some underlying abstract theme, its roots, perhaps, in the teaching of the Zen sect of Buddhism, and beyond the reach of the unaided eye. But the colour-print triptychs, beginning in the Primitive period as three related figures printed adjacent to one another on a single sheet of paper (and usually cut into three by the owner), led to the diptych and triptych of Kiyonaga's time onward, in which the whole design was carried over two or three sheets which were intended to be joined at their edges, though, by a remarkable feat of designing, each sheet can be enjoyed as an independent entity, with no disturbing sensation that companion sheets are lacking to complete the picture.

Though uncommon, prints were produced comprising five sheets or more, and these more nearly correspond to the *makimono* or laterally-rolled painting. It was more often intended, I think, that these panoramic prints should be viewed, not as a single composition but piecemeal, a few sheets at a time, just as the old *makimono* was unrolled to reveal only as much as the eye could take in at a glance.

Surimono (literally 'printed-things') were prints issued for some specific occasion, as New Year's greetings, to celebrate a birth or a marriage, to commemorate a new membership to a poetry club, or to give notice of an author's or artist's change of name, no rare event; or were simply a vehicle for publishing the verses of the members of poetry clubs. They are usually of small size and characterized by the extreme delicacy of the printing, the lavish use of metal-dusts and *gauffrage*, and the welding of design and poetry into a decorative whole. Shunman, Hokusai and his pupils Hokkei, Shinsai and Gakutei excelled in these miniature works of art, which sometimes seem to trespass into the realm of the lacquerer.

The *hashirakake*, 'pillar-hanging' print, is, of all the formats used by the designers, the most essentially Japanese, and without a counterpart in Western art. Intended as a decoration for the wooden pillars that were a feature of the lightly-constructed houses of the country, the difficulties of designing within the tall, narrow limits of the panel seem to have challenged the Ukiyo-e artists to some of their finest achievements, comparable to the way that the limitation to seventeen syllables, all that the favourite form of lyric permitted, inspired the poets to remarkable feats of expressive compression. Harunobu, and especially Koryusai, are the great masters of the *hashirakake* (or *hashira-e*), but Kiyonaga, Shuncho, Utamaro, Toyohiro and most of the outstanding artists of the latter end of the eighteenth century produced fine prints of this kind.

THE PRINT-SELLERS' PUBLIC

The colour-print's appeal to us is only in part due to the actual style of the Ukiyo-e school: it resides as much in the portrayal of a world utterly remote from our own, with dress, behaviour

and custom intensely national, or influenced only from a quarter equally remote from us, China. It is this fusion of alien subject and individual style that makes the colour-print far more a national art, a 'folk' art if you will, than, say, Italian painting, however distinctive the latter may seem in relation to other European styles.

The formation of the new social class has already been touched upon as being the genesis of the colour-print. The character of the people of this plebeian class, their customs and daily life, their culture, have an intimate bearing on the nature of the prints.

Geographically, the Japanese are an isolated race. This insularity was accentuated in 1638, at a time when the Tokugawa regime was fully established, by laws proscribing intercourse with countries outside Japan; a policy that had its strength in that it preserved the country from distracting foreign influences, in the way of modern totalitarianism; and its weaknesses, that came from denying the people the broadening influence of other ways of life, other philosophies, than their own, and of the benefits, albeit sometimes doubtful, of scientific progress being made elsewhere. But in respect of their art, the effect of the seclusion was wholly good, if one is to judge by the Europeanization that, after the revolution of 1868, ensued with results completely disastrous to the national genius.

But just as in-breeding leads to certain perversions and degenerate types, so in the Japan of this period there is something febrile and unbalanced: it is a world of rigid etiquette and extreme fastidiousness in dress, where, quite apart from the drama, men are often posed in feminine attire; and yet a world of the utmost grossness and brutality, where self-immolation is decreed for a peccadillo, and any crime sanctioned in the cause of revenge.

Too great a stress has often been placed, I think, on the low station and vulgar taste of the people to whom the prints were purveyed. From the very nature of many of the prints, the refinement of the sentiment expressed, the artist's evident familiarity with classic poetry, it is obvious that they were acquired by people whose tastes were anything but coarse. There is a likeness here— it has been remarked before—between the people of Elizabethan England and the Japanese of the Edo period; we are constantly surprised at the richness of allusion in Shakespeare, which modern editors need copious commentaries to explain, but which was a matter of everyday knowledge to the frequenters of the 'Globe'.

The eighteenth century saw, in fact, not only the increase in the literacy of those of lowest station, but also an intermingling of the military and controlling class with the wealthier merchants, considered very low in the social scale, and intermarriage between such disparates, unthinkable earlier, also helped to break down the former rigid barriers. It is well known that the *Kabuki* Theatre, though considered an amusement for the lower classes, was, even if only clandestinely, frequented by the two-sworded men, the *samurai*, and we may be sure that many of the prints, and the finest of the illustrated books, were intended for the same exalted class. In a book of Hokusai's, 'The Pleasures of Edo', 1802, there is a picture of the print-shop of Tsutaya Jusaburo, one of the leading publishers of the day, with a *samurai* standing at the counter and showing a marked interest in the colour-prints; and a picture of a *samurai* seated in another publisher's shop. engrossed in one of the Ukiyo-e picture books, appears in a book of 1801 illustrated by Toyokuni, The work of Harunobu, Eishi, Utamaro, and Shunman, to cite only four, is often of that hyper-refinement termed by the Japanese *shibui*, and would assuredly have been lost on the vulgar herd.

13

But that there were extremes in the vast populace of Edo is not to be doubted, and the literature of the time, which, like the arts of the lacquerer and the potter, the silk-weaver and the painter, received new impetus and created new forms in the dynamic atmosphere of the period, ranges from moral and religious treatises of the *Kangakusha*, the enthusiasts for all things Chinese, to *kibyoshi*, 'yellow-backs' and fiction of various kinds, often of a pornographic type. Of this literature, by which some judgement of the taste and mental calibre of the people can be made, W. G. Aston wrote, 'But while the new literature is much richer and of a more vigorous growth than the old, there is a sad falling off in the point of form . . . Extravagance, false sentiment, defiance of probability, whether physical or moral, pedantry, pornography, puns and meretricious ornaments of style, intolerable platitudes, impossible adventures and weary wastes of useless detail meet us everywhere.'

As might be expected, the Ukiyo-e artists, as regards the subject-matter of their prints, can often be taxed with similar faults, but generally, certainly until the decline of the art in the nineteenth century, the age-old traditions of draughtsmanship and design still exerted a powerful influence, not lessened by affiliation to the new school. As an instance, one might take the books of erotic pictures. Practically every artist was responsible for books of this nature, books which were half-heartedly banned from time to time, but usually only slightly frowned upon by the authorities: but even in these the artists never forsook their high principles of drawing and composition, and, in fact, artists like Eishi and Utamaro seemed to find fresh access of powers in grappling with the problems set by imbroglios of nude and semi-nude figures, and some of their finest designs, reproduced by the most sumptuous colour-printing, are to be found in these *shunga*, 'Spring-drawings', as the erotic pictures are called.

Judged by their literature, and by the majority of the prints and picture-books, the commoners and their more aristocratic congeners were obsessed with a love of the gay, the fast, life: modern Japanese, in fact, translate the word *Ukiyo-e* as 'Pictures of Gay Life'. Prints and books are replete with pictures of pleasure-parties in the town, the countryside or along the river, the youth of both sexes freely intermingling and philandering, often to the accompaniment of music, and with the *sake*-kettle always ready to hand. The Yoshiwara, the brothel quarter, was a constant preoccupation of the Ukiyo-e artists, and the *Kabuki* theatre provided almost as many subjects. These, with *kacho* (pictures of birds and flowers), and landscape, a later, nineteenth-century development, form the subject matter of the prints, a little more detailed consideration of which is an aid to appreciating the nature of the people, and the art of the print-designers.

THE COURTESAN AND THE 'GAY LIFE'

The courtesan was, in all senses of the word, a public figure. Accepted by the authorities as an inevitable feature of town life—the large numbers of officials quartered in Edo without their families, and the lack of romance in the pre-arranged marriage of the country were partial causes—the Yoshiwara in Edo and similar establishments there and elsewhere were set apart for licensed prostitution. The Yoshiwara became the haunt of most of the artists and writers of the time in search of 'copy', for the town-dwellers were always avid for pictures of the

'Green-Houses', of the colourful life of this world-within-a-world, and especially for portraits of the denizens, the courtesans, from the *tayu*, the queen of her calling, and the *oiran*, the next in the hierarchy, down to the acolytes of the profession, the *shinzo* and *kamuro*.

The higher-class courtesans, destined for those of high rank or great wealth, were trained from children to become fit consorts for such men. They bore themselves like princesses, whose accomplishments they emulated, learning to speak the ancient poetic language, practising the arts of music, painting and poetry, and carrying themselves in their gorgeous apparel with regal grace.

Various factors led to their popularity with the colour-print artists, apart from the public demand for pictures of the reigning beauties. Though these were never portraits in our sense of the term, they were unquestionably fashion-plates, and to a nation such as the Japanese, where both men and women were absorbed in matters of dress, the patterns and colours of silks, this was a major attraction. In a celebrated book of 1776, entitled 'A Mirror of Beauties of the Green-Houses', illustrated by Shigemasa and Shunsho, the publisher, Tsutaya Jusaburo, calls attention in a preface to the Japanese artists' preoccupation with 'the fashions of costume and hairdressing prevalent at each age, which pass as rapidly as the infant growing to manhood'; and from Moronobu onwards, the changes in dress fashions, in the motifs of the silk-designers, but especially the alterations in coiffure styles, are marked enough to date the prints with some reliability. The features of a girl's face often seemed of less concern to the artist than the set of her hair, the drawing of which, with its complement of combs, was always given in considerable detail. One could easily believe that with the Japanese the hair was in truth 'a woman's crowning glory', and the beautiful, and often eccentric, shapes into which it was forced, play a large part in the pattern of the print-designers' compositions.

But the sway of fashion in Japan was not limited to dress or coiffure: the prints give clear evidence of the vogue of certain physical types: the tall, majestic figure of the Primitives giving way gradually to the improbable *petite* of Harunobu, and this to the immensely tall and slim forms affected by Kiyonaga, Eishi and Utamaro. In the artists' drawings, there was rarely any truth to the actual Japanese feminine form: in this again the artists showed their complete independence of the dictates of nature. The actual build of the average Japanese woman was, and is, short and a little dumpy, but this did not prevent the artists from imparting to their models the ample majesty of the Parthenon 'Fates', or the dainty sprightliness of Watteau's shepherdesses, or the willowy grace of Modigliani's attenuated creatures: all in accordance with the canon of proportions dictated by the current leaders of fashion.

The 'Pleasures of Edo' is the title on scores of colour-print books and on a multitude of prints. Usually, they depict the gallants escorting courtesans and their more virtuous associates, the geishas, in the well-known thoroughfares of the town, making their way to a popular rendezvous, tea-house or theatre; or in pleasure-boats on the Sumida river, the favourite setting for trifling amours and mild debauchery; or in the lovely gardens abounding in the purlieus of Edo, rapt in admiration of the flowering cherry trees, perhaps, or of the red maple leaves floating on a pool.

The town of Edo, itself like a huge pleasure-garden with impermanent-looking houses and bridges of fanciful shape spanning the river, was often *en fête*. Each month had its own festival celebrated with spectacular processions and pageantry, regattas on the river and firework displays,

providing the Ukiyo-e artists with wonderful opportunities for compositions crowded with figures in flamboyant costumes, and alive with the gaiety and abandon of carnival.

At other times, we are given glimpses of the interiors of the Yoshiwara apartments, of the ceremonial of the 'courtship' preceding 'full knowledge'. Or the women are seen alone, idling the day away in decorous pursuits, writing long love-letters, displaying a new dress to companions, amusing themselves with pet animals, or with battledore or yo-yo.

As the eighteenth century waned, there were other reasons for the popularity of the Yoshiwara among the artists and intellectuals generally. The unrest in the country caused by the ferment against the Shogunate led to repressive measures, and many of the men who sowed the seed that came to fruition in the revolution of 1868 found sanctuary in the precincts of the Yoshiwara, which became a cloak for the 'underground' movement, a place where freedom of thought and speech was possible despite harsh laws. In the luxuriously appointed quarters of the Yoshiwara, literary wits of the time like Kitao Masanobu and Jippensha Ikku (themselves both designers of prints), Utamaro, Toyokuni and their fellow artists, rubbed shoulders with the political firebrands seeking refuge there, and something of the charged atmosphere, the undercurrent of violence beneath the froth and sparkle of wit, gives the prints of the late eighteenth century a strangely disturbing character, a sort of *fin-de-siècle* sophistication new to Japanese art.

THE THEATRE

The theatre was, to the Edo commoner, all part of the 'Gay Life'. It was recorded assiduously by the Ukiyo-e artists, and some of the finest prints of the school are of actors in character.

The *Kabuki* theatre originated in the seventeenth century, only a few decades before the Ukiyo-e school began to find its outlet in the illustration of books. It was a composite, combining features from the old dances of Japan, from the classical *No* drama of the aristocracy, and from the already popular puppet stage. The *Kabuki* was a typical product of the new class: the stiff brocade and ritualistic dance of the *No* plays were replaced by fashionable silk and greater freedom of movement, the recondite acted poetry gave way to something more nearly approaching realism in speech and action, even though to our intelligence both are still mannered and non-naturalistic. The art of the *Kabuki* theatre was as much visual as literary, partaking in some degree of the character of our ballet, though the movements were more restricted, the drama more intense, and the tempo so slow that at times the stage seemed to present a series of colourful tableaux. The plays were sanguinary, full of violence, heroics and bathotic situations, and hardly stand high as literature, but they provided magnificent material for the colour-print designers, certain sub-schools coming into being primarily as recorders of stage performances and as portrait-makers of the actors.

Most Ukiyo-e artists at one time or another took the stage as their subject, but to three families of artists in particular we are indebted for the finest work in this sphere: the Torii, of whom Kiyonobu, Kiyomasu, Kiyohiro, Kiyomitsu and Kiyonaga are the great masters; the Katsukawa, Shunsho and his pupils Shunko and Shunyei and others less well known; and the Utagawa, of whom Toyokuni, Kunimasa, Kunisada and Kuniyoshi are the principal designers.

In their prints, little attempt is made to give the scene of a play, a few unobtrusive 'props' being all that was required to set the stage for the fanatical theatre-goers. Normally, the prints depict either a single actor, or less often, two, in character, and from Kiyonobu onwards, the artists show a wonderful ingenuity in composing a rhythmic design based on a single figure, or two in a sort of *pas-de-deux*. As on the Elizabethan stage, only male performers were permitted, but certain families of actors specialised in female parts, and judging by the prints, their impersonations seem to have been deceptively life-like. Few can resist the charm of the 'girl' holding an umbrella in Buncho's magical print (Plate 15) and it is hard to believe that the model for such feminine grace of movement was a male actor.

Shunsho is one of the greatest masters of the actor-print, and at his best delights us with the dancing arabesque of his figures against a slightly indicated back-drop, using a simple outline and flat tones of soft harmonious colouring. Yet, despite the absence of what we call realism, he gives us a convincing picture of the actors of the Edo theatres. One Western writer, Mr. Osman Edwards, familiar with the *Kabuki* performances, wrote, 'To watch act after act of their spectacular tragedies is like looking through a portfolio of their best colour-prints.'

The prints of Sharaku need special mention, because although founded in the tradition of the theatrical colour-print, they have qualities that distinguish them at once from all other prints of the same order. The intensity of characterization, the forcible draughtsmanship, the bizarre and sinister harmonies of colour, accentuated by the dark mica-grounds of most, compel attention although they may disturb or even revolt us. The staring eyeballs, the unnatural grimace, are no more than an interpretation of the intensity of expression affected by the actors, though in some of the prints there are, I think, the marks of a master who, like Cézanne sometimes, has to struggle to express himself, hampered and angered by the limitations of his medium. Perhaps the most astonishing thing to relate in connection with Sharaku's prints, not unconnected with this sense of a giant wrestling with an intractable medium, is that they were all produced in one year, 1794, and that there is no evidence to show that the artist, a *No* dancer by profession, had ever designed a colour-print before that date.

KACHO-E AND LANDSCAPE

From earliest times, the Japanese people were united in an unfeigned devotion to nature. Literature, legend, painting, ceramic and textile all bear testimony to an innate love of flowers and trees, birds and animals, and all the natural features of the countryside. The rising of the new moon was celebrated by gatherings of people who composed lyrics as they watched the sky; the flowering of the cherry-trees was made the occasion for 'viewing-parties'; the red leaves of the autumn maples, and the first falls of snow, brought admiring groups into the countryside; the mountains and lakes of their beautiful land were literally worshipped—who can forget the picture in Hokusai's book 'The One-hundred Views of Fuji' of an old man kneeling before a circular window framing a distant view of Fuji and flinging back his head in an ecstasy of delight at the vision? Poems extolling the Peerless Mountain, Lake Biwa and the lesser known features of every province, are legion.

In art, this deep feeling for nature gave rise to a pure landscape art long before such a thing appeared in European painting, and also, to paintings of 'birds and flowers', *kacho-e*, that really have no counterpart in our art at all. The greatest painters of the Kano and Chinese schools excelled in paintings of these two kinds, and their works were revered with something next to idolatry, the finest resting in the temples as objects of devotion.

As will be mentioned shortly, the Ukiyo-e artists were inclined to deal in a rather cavalier manner with the subjects hallowed by antiquity and traditionally associated with the aristocratic schools of painting, but in their landscape and *kacho* art, though still unmistakably Ukiyo-e in timbre, the note is often of great sincerity, and the humble prints challenge comparison with the paintings of Sesshu and Motonobu, So-ami and Chokuan, and other giants of the past.

There are early *kacho-e* from the hands of such primitives as Kiyomasu, Shigenaga and others, whose drawings of hawks, for instance, in striking black line only, are often of an impressive magniloquence: but Harunobu and Koryusai, Utamaro, Hokusai and Hiroshige, with the greater resources of the colour-print proper at their command, excelled in this field, producing exquisite designs of birds and animals that exemplify the astonishing power of the Japanese to synthesize and conventionalize natural forms, to bring them into an ordered pattern, without destroying the illusion of life, of actuality.

The art of the popular school was primarily in *genre* painting, manners and modes of the ordinary life of the day, and from the earliest book illustrations it was habitual to set the scene with a glimpse of tree or stream, the outline of tea-house or Yoshiwara, in the background. However, landscape, as an independent art, appeared late in the prints, though Toyoharu with his Europeanized *Uki-e* 'bird's-eye-view' prints may be an exception to the rule. By the time of Kiyonaga, Eishi and Utamaro, the background was often given greater prominence, and in their *plein air* pictures, the pleasure-gardens, the streets of Edo, the river-front, are effectively sketched in. Utamaro, in some albums of about 1790, produced some prints that are pure landscape, but it was left to Hokusai and Hiroshige to develop this last achievement of the colour-print art, one that, with our natural bias towards landscape art, delights us more spontaneously than any other.

Hokusai's landscape prints, though based on the age-old traditions, are daringly innovating, and owe much of their *éclat* to the colour-print technique. This medium, imposing broad treatment, firm outline and flat washes of colour, seemed to inspire him to design in a synoptic manner, disdaining the accidents of topography and weather the better to achieve the essential hill, the eternal sea: though, in the true Ukiyo-e vein, it is only rarely that man is absent, dwarfed and intimidated though he may be by the elemental forces and forms around him.

Hiroshige is a milder and gentler spirit altogether, the figures, the human element, loom larger in the foreground, and generally we feel that we are in a land where rain and moonlight are much as they are with us. Our sympathies are won over not only by his artistry, but by the sense that, though essentially Japanese, he is in some indefinable way closer to us, in style and sentiment, than any of his forerunners, and his brush-drawings bring this out, if anything, more clearly.

LEGEND AND HISTORY

It is testimony to that strange duality in the life of the Japanese to which reference has already been made, the indulgence in all forms of sensuous pleasure and an ardent appreciation of the arts against a background of violence, fanatical loyalty and revenge, to us wholly barbaric, that the Ukiyo-e artists often turned from the blandishments of the 'Green-Houses' and the theatre to subjects from heroic legends, and particularly from the bloody events of mediaeval history, barely distinguishable themselves in the passage of time from the most improbable of the legends.

Chief among these legendary histories, or historical romances, are those dealing with the civil wars of the middle ages between the two dominant clans, the Minamoto and Taira. The stirring events of these wars, the great battles and the individual feats of chivalry and derring-do recur again and again, few artists being able to resist this type of print, perhaps because an innate nationalistic pride in the past led to the unfailing popularity with the public of such depictions. Even those artists whose charm lies in an essentially feminine grace, Harunobu, for instance, or Shunzan, became changed spirits as they buckled on the cumbrous old armour and turned manfully to the warlike themes, the fight on Gojo Bridge, for example, between Yoshitsune and the giant Benkei—a favourite subject—or Hachimantaro, heroic youth of the Minamoto clan, performing prodigies of valour.

But the great master of these scenes of strife is unquestionably Kuniyoshi, who, in the middle of the nineteenth century, produced a huge number of powerful designs, many of them in triptych form, that convey a sense of turbulence and pageantry that has a reality of its own, whatever relation it may bear to historical fact.

PARODY, TRAVESTY, BURLESQUE, AND ANALOGUE

The newcomer to Ukiyo-e art will often be puzzled by the artists' oblique manner of illustrating a given theme, and by the even less straightforward manner of entitling prints. Subjects reverently painted by artists of the established schools are whimsically enacted by courtesan and paramour in 'modern dress'; and going further, by an odd transmogrification, classical landscapes and famous views are personified by women of the Green-Houses, whose trivial occupations are ingeniously made to suggest, by remote analogy, famous places and events, and the classical painters' representations of them.

The Seven Famous Scenes in the life of the poetess Komachi were handled in this way by nearly every Ukiyo-e artist of note: a mother and child, for instance, looking in a mirror, are made to do service for the 'Komachi and the Parrot' scene, the pun-loving Japanese seeing an immediate connection between the 'Echo-poem' returned by Komachi to the Emperor Yosai, using all the same characters save one that comprised his own poem, and the two reflected faces in the mirror. Even more popular was the linking of the traditional 'Eight Views of Lake Biwa' with scenes in domestic life: in the print of Harunobu reproduced (Plate 16) there is a typical Ukiyo-e 'take-off' of the 'Evening Bell of Miidera'.

Other favourite subjects with the Kano painters, the jolly madmen Kanzan and Jitoku,

traditionally shown as ragamuffin figures, one with a scroll, the other with a besom broom, are represented by girls attired *à la mode*, a love-letter taking the place of the scroll, and as often as not, a guitar serving for the besom. The six famous 'jewel-rivers' of Japan were invariably personified by gorgeously apparelled women of the Yoshiwara, some pattern of their robe or some action whose significance may be lost upon us, giving the locality of each river.

Parody and travesty are hardly exact words for this sort of thing, though occasionally the playful treatment of well-known stories or legends amounts almost to burlesque: as for example, the enactment of the tenth-century court scenes from the Genji Romance by fashionable ladies of the demi-monde, and the representation of scenes from the popular melodrama 'The Forty-Seven Ronin' by pictures of domestic squabble or low-life courtship, far-fetched parallels to which a clue was often given by a small inset drawing of the actual scene burlesqued.

THE ART OF UKIYO-E

The study of a piece of music, a *Lied* of Hugo Wolf's for example, an analysis of the score and a translation of the lyric, brings us only a little way towards an appreciation of the musician's art, which lies in the fusion of words and accompaniment, and can be judged by the sounds alone. Having glanced at the environment of the Ukiyo-e artists, the class of people for whom their art came into being, the technique and the subject-matter of the prints, there is still something to be added concerning the especial aesthetic appeal of the prints, an appeal as difficult to translate into words as that of rhythm, melody and counterpoint. Primarily, it is a matter of pure design, of the fusion of line and colour, subject and composition, into 'pictorial music', addressed to our sight as the *Lied* is to our hearing.

Of the pictorial art of few other nations can it be said that it compares with that of the Japanese print-designers in so nearly achieving that aspiration towards a 'condition of music', tardily accepted in Europe as the ultimate aim of graphic art. A knowledge of the language, customs, history, literature and legends of the country may in some cases aid our appreciation, but at other times may actually interfere with the more purely emotional acceptance of the print as a work of art, returning a magic amalgam into its separate elements.

Founded, for all its revolutionary character, in a tradition of painting that had never adopted mere representationalism as one of its tenets, and aided by a medium that inhibited any tendency to elaborate beyond firm outlines and flat tones of colour, the art of the Ukiyo-e artists stands or falls ultimately on an assessment of its design: and there are many who will agree with Laurence Binyon and O'Brien Sexton whose considered opinion was that 'As pure design, this body of work is unrivalled in any other country, unless perhaps by Greek vases.'

Given a space to fill, the Japanese designers seem to have had an innate gift for decorating it in a manner felt by us to be inevitable. This is brought home most clearly, perhaps, in the *kacho-e* of Harunobu, Koryusai, Utamaro and Hokusai, in which the shapes and colours of bird and flower are brought with masterly skill into compositions that satisfy us like rounded melodies, and are unerringly given the perfect *mise-en-page*. In the process, just as the faces of the courtesans are reduced in other prints to a few expressive lines, the minutiae of fur and feather may be sacrificed,

and botanically the flowers might not convince Bentham and Hooker: but the drawings bring out the essentials, the plant really seems to be growing, the bird is unmistakably alive and capable of flight.

But this genius for synthesis is not limited to their designs for *kacho-e*: its greatest triumphs were in the drawing of the human form. 'Art is first of all unity of impression,' wrote Fenollosa, 'but into this unity can be thrown and melted every serviceable form that generous nature can supply.' In the figure designs, comprising by far the greater proportion of the prints, there is the same reduction to essentials, the same insistence on pattern. The relation of figure to figure may seem accidental, the pose of each naturalistic, but in reality, the arrangements are quite artificial, as much bent to the artist's will as the artfully placed spray of flowers or the bird on the wing.

In landscape, too, the utmost ingenuity and invention are brought to bear in composition. Hokusai is undoubtedly supreme in this power of reducing the disorder of nature to a formal pattern that still has the impress of actuality and is never mere conventionalized form. The series of forty-six prints entitled 'The Thirty-six Views of Mount Fuji', the cone-shaped mountain appearing in each print like a *leit-motif*, is a display of virtuosity akin to the Diabelli Variations of Beethoven: and for daring composition even these are excelled by the series of 'Waterfalls'. Hiroshige combines a faculty for pictorial pattern with great use of the unusual viewpoint. The snow-covered fields around Edo are seen from a great height with the eyes of an eagle, whose outspread wings fill the upper part of the design; the Iris Gardens of Horikiri are glimpsed through the irises themselves, brought close to the viewer's eyes; the bow-moon, in a famous print, is seen low down in the sky between precipitous cliffs that soar to each side of the panel (Plate 46).

In these achievements of the figure-designers and landscapists in the realm of composition, their sacrifice of detail and bold synthesis of natural forms, their adoption of the unusual angle or view-point in the cause of a telling design, in all this there may seem little that is novel to us today. But the impact and effect on European art in the nineteenth century cannot be over-estimated. The growth during the century among European artists of the conception of an art based on, rather than tied to, nature, the breaking away from the dogma of representing 'things as they are seen', was due indirectly to the lesson of the East: and many painters were directly influenced by the design of the Ukiyo-e artists, their manner of employing human form and landscape feature as elements of a pictorial pattern. Degas, Manet, Gauguin, Van Gogh, Toulouse-Lautrec, Bonnard, Beardsley, the Beggarstaff Brothers—to take a number of artists at random—all show indebtedness at one phase or another of their work to the designers of the Japanese colour-prints.

By a sad turning of the tables, the influence of Western art on the Japanese in the nineteenth century was to cause first a flirting with, then a complete subjection to, the very representational method already, by their example, discredited in the West. Water-colour was forsaken for oil-paint, quite inimical to their native technique, and the traditional styles of painting that had prevailed for centuries and given rise to a body of painting unique in character, were thrown over for imitations of European methods, mostly of a debased 'photographic' type.

But the influence of alien models can hardly be held to account for the deterioration in the art of the Ukiyo-e school. Even before the country was opened up to foreigners in 1853, in fact

from the beginning of the century, there were signs of a falling off from the high standards that had prevailed until then, and the broadsheets, issued now in vast numbers for an increasingly uncritical public, gradually became poorer in the quality both of the designs and of the colour-printing. Hokusai and certain of his pupils; Hiroshige; Kuniyoshi, and, for a time, Kunisada, continued to produce fine prints, despite the evil effect on the colour-printing caused by the replacement of vegetable colours by aniline dyes of foreign manufacture; but by the time of the Revolution of 1868, the art of the Ukiyo-e colour-print was dead. There were attempts to revive the art later in the century, and the block-cutters, at least, showed that they had not forgotten their craft: but the designers' art had been finally vitiated by contact with the West, and few of the later prints rise above either ineffectual prettiness, or violently coloured melodrama.

List of plates

23

Plate 25: KITAO MASANOBU (1761–1816). *The courtesans Hitomoto and Tagosode*. Diptych from the album 'The Autographs of Yoshiwara Beauties'. 37 × 50 cm. 1783. (Author's Collection.)

Plate 26: TORII KIYONAGA (1752–1815). *Cherry-blossom at Asakayama near Edo*. Centre sheet of a triptych. 37 × 24 cm. About 1787/8. (British Museum.)

Plate 27: KUBO SHUNMAN (1757–1820). *The Toi, one of the 'Six Jewel Rivers'*. Part of a six-sheet composition. 37 × 25 cm. About 1787. (British Museum.)

Plate 28: KATSUKAWA SHUNKO (died 1827). *Head of a male actor taking a female part*. 38 × 25 cm. About 1787/9. (Amstutz Collection, Mannendorf, Switzerland.)

Plate 29: YUSHIDO SHUNCHO (active c. 1780–1800). *The wrestler Onogawa and the tea-house waitress O'hisa*. 39 × 25 cm. About 1792. (British Museum.)

Plate 30: CHOBUNSAI EISHI (1756–1829). *Komurasaki sitting on her heels*. One of a series in which courtesans impersonate the Six Great Poets. 39 × 26 cm. About 1794/5. (Art Institute of Chicago.)

Plate 31: KITAGAWA UTAMARO (1753–1806). *'The Passionate Type'*. From the 'Ten Learned Studies of Women', on mica-ground. 38 × 25 cm. About 1792/3. (British Museum.)

Plate 32: TOSHUSAI SHARAKU (print activity confined to 1794). *The actor Segawa Tomisaburo as Yadorigi in a play performed in 1794*. 36 × 24 cm. (British Museum.)

Plate 33: TOSHUSAI SHARAKU. *The actors Nakamura Konozo and Nakajima Wadaemon in character*. Mica-ground. 37 × 23 cm. 1794. (British Museum.)

Plate 34: CHOBUNSAI EISHI (1756–1829). *The courtesan Itsutomi holding a plectrum*. Mica-ground. 38 × 25 cm. About 1794. (Victoria and Albert Museum.)

Plate 35: EIRI (worked 1789–1800). *Woman walking with a towel over her shoulder*. One of a set of three. 37 × 26 cm. About 1795. (Musée Guimet, Paris.)

Plate 36: CHOKOSAI EISHO (active 1785–1800. *Head of a girl in a transparent hood*. 24 × 37 cm. About 1795/6. (Grabhorn Collection, San Francisco.)

Plate 37: UTAGAWA KUNIMASA (active 1795–1810). *The actor Ichikawa Ebizo in the Shibaraku episode in a play performed in 1796*. 39 × 26 cm. (British Museum.)

Plate 38: KITAGAWA UTAMARO (1753–1806). *The lovers Hambei and O'chie*. From a series 'An Array of Passionate Lovers'. 36 × 24 cm. 1797/8. (British Museum.)

Plate 39: KATSUKAWA SHUNEI (1768–1819). *The wrestler Tanikaze and his pupil Taki-no-oto*. 38 × 25 cm. About 1796. (British Museum.)

Plate 40: UTAGAWA TOYOKUNI (1769–1825). *The actor Iwai Hanshiro in a feminine role, in a play performed in 1795*. From the series 'Actors as they appear on the stage'. 38 × 25 cm. (Honolulu Academy of Arts, C. Montague Cooke Jr. Memorial Collection.)

Plate 41: KATSUKAWA SHUNEI (1768–1819). *The actor Nakayama Tomisaburo as the courtesan O'karu in a play performed in 1795*. 38 × 26 cm. (Honolulu Academy of Arts, Michener Collection.)

Plate 42: KATSUSHIKA HOKUSAI (1760–1849). *Cuckoo and azalea*. From the series known as the 'Small Flowers'. 25 × 18 cm. About 1828. (British Museum.)

Plate 43: KATSUSHIKA HOKUSAI (1760–1849). *The Waterfall of Yoshino*. From the series 'Going the Round of the Waterfalls of the Country'. 38 × 25 cm. About 1830. (Ralph Harari Collection, London.)

Plate 44: KATSUSHIKA HOKUSAI (1760–1849). *Fuji in clear weather*. From the series 'The Thirty-six Views of Fuji'. 26 × 38 cm. About 1823/9. (British Museum.)

Plate 45: ANDO HIROSHIGE (1795–1858). *Moonlight, Nagakubo*. One of the 'Sixty-nine Stations of the Kisakaido'. 22 × 35 cm. About 1840. (British Museum.)

Plate 46: ANDO HIROSHIGE (1795–1858). *The Bow Moon*. One of a set that was to be twenty-eight in number, but of which only two are known. 38 × 16 cm. About 1830/5. (Private Collection.)

Plate 47: UTAGAWA KUNIYOSHI (1797–1861). *Tameijiro dan Shogo, one of the 108 Heroes of the Suikoden, grappling with an adversary under water*. 38 × 26 cm. 1827/30. (B. W. Robinson Collection, London.)

Plate 48: UTAGAWA KUNISADA (1786–1864). *The actor Ichikawa Danjuro VII in character*. Mica-ground. From a *Kyogen* set of half-length figures that contain some of the artist's finest actor-prints. 38 × 26 cm. About 1820. (Janette Ostier Collection, Paris.)

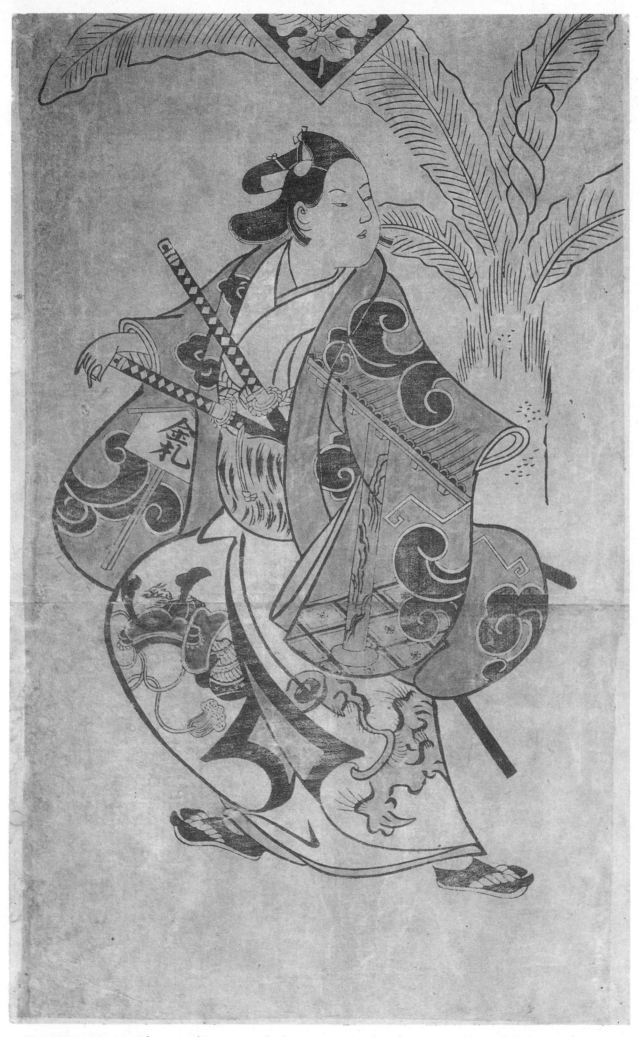

1. TORII KIYONOBU I: *The actor Shinomiya Heihachi in a samurai role*. About 1700-1705. Chicago, Art Institute

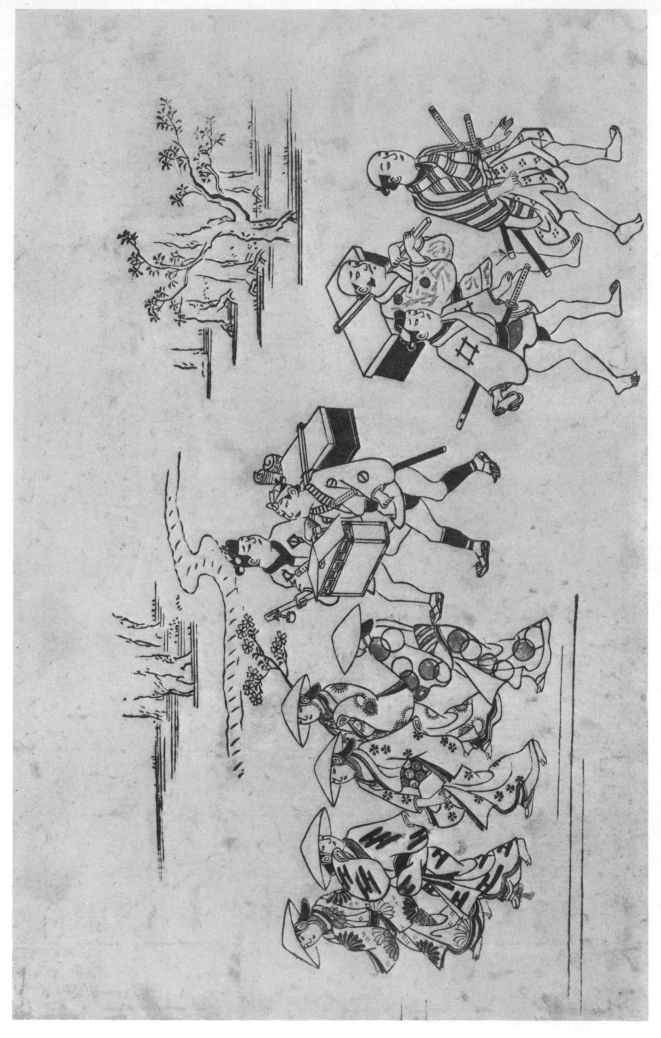

2. HISHIKAWA MORONOBU: *Returning from a flower-picnic*. About 1680. London, British Museum

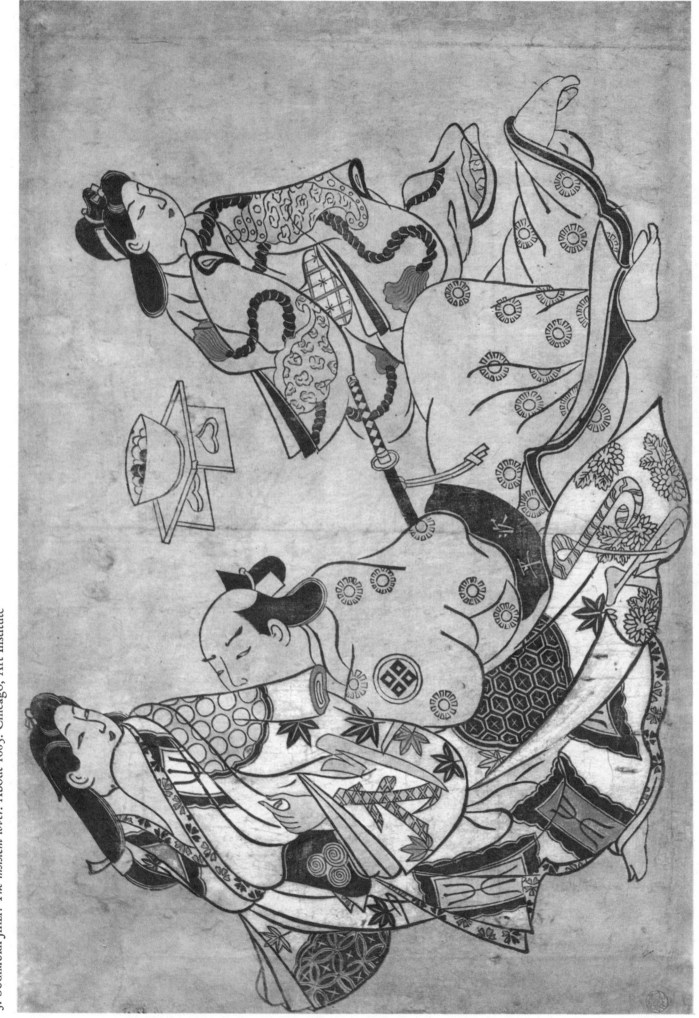

3. SUGIMURA JIHEI: *The insistent lover.* About 1685. Chicago, Art Institute

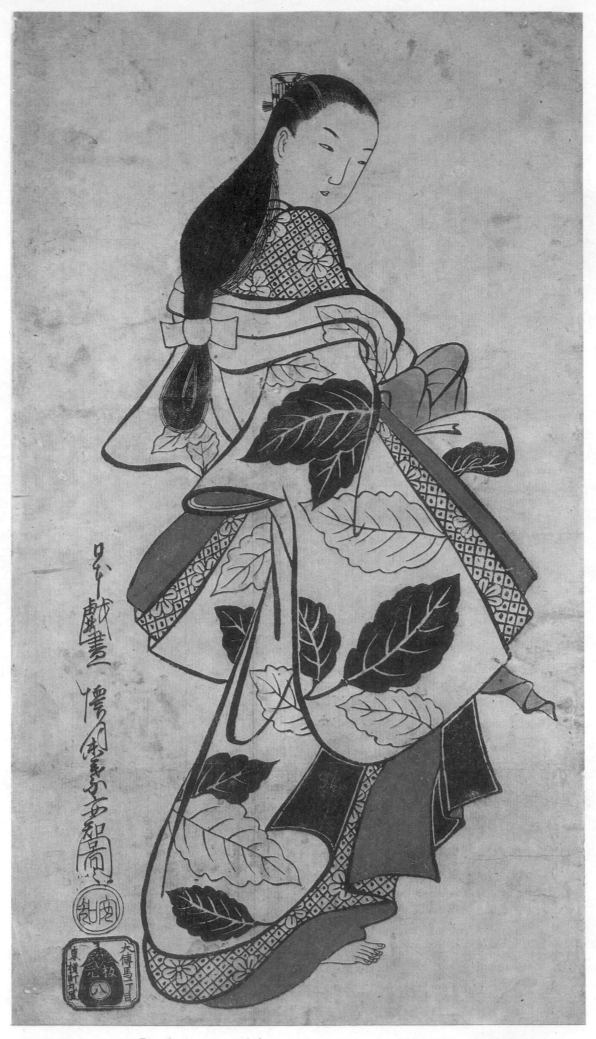

4. KAIGETSUDO ANCHI: *Standing courtesan*. About 1714-1715. San Francisco, Grabhorn Collection

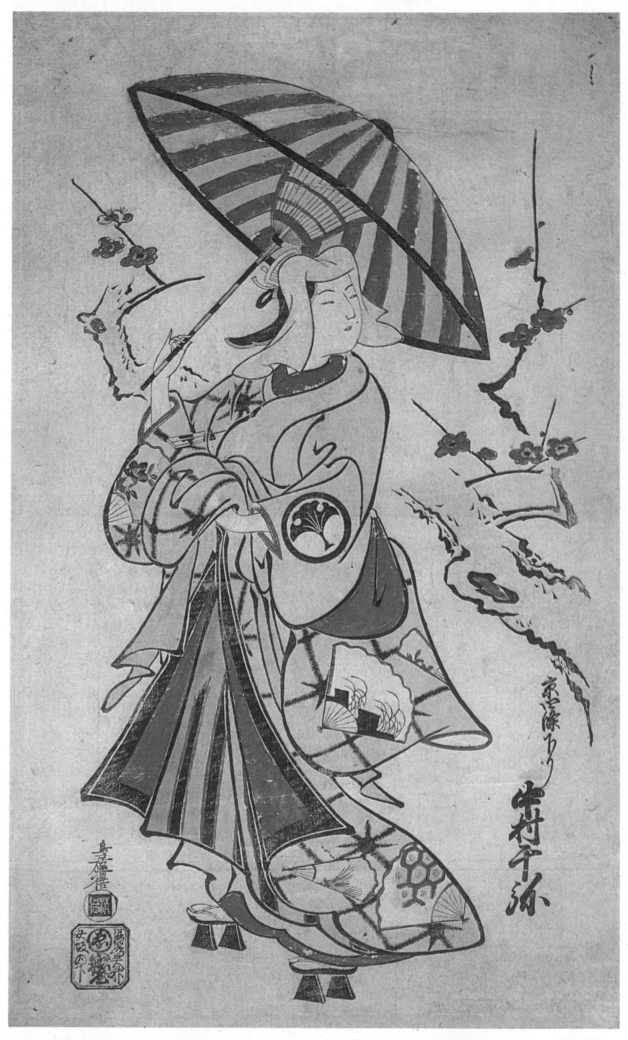

5. TORII KIYOMASU I: *The actor Nakamura Senya in the role of Tokonotsu.* 1716. Honolulu Academy of Arts, Hawaii, Michener Collection

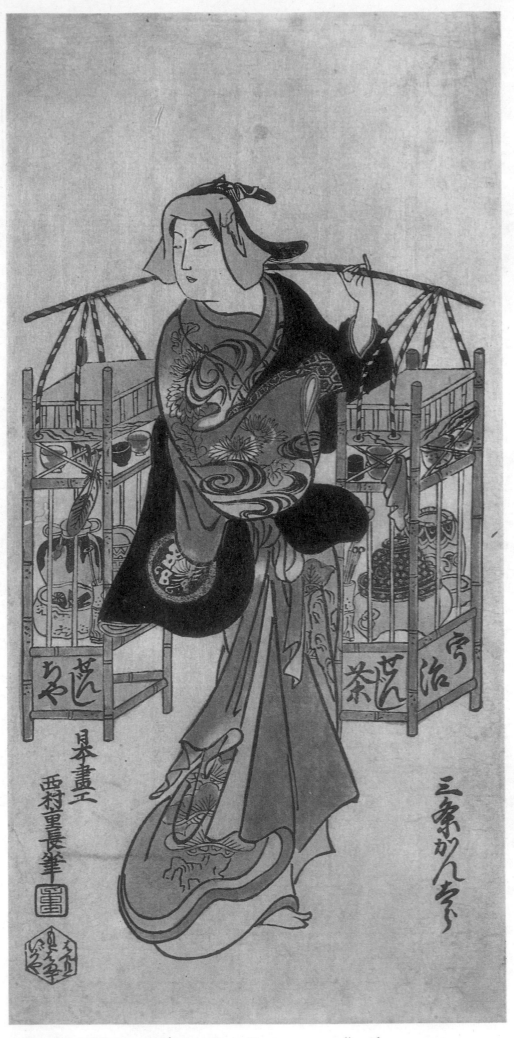

6. NISHIMURA SHIGENAGA: *The actor Sanyo Kantaro as a tea-seller*. About 1725.
London, British Museum

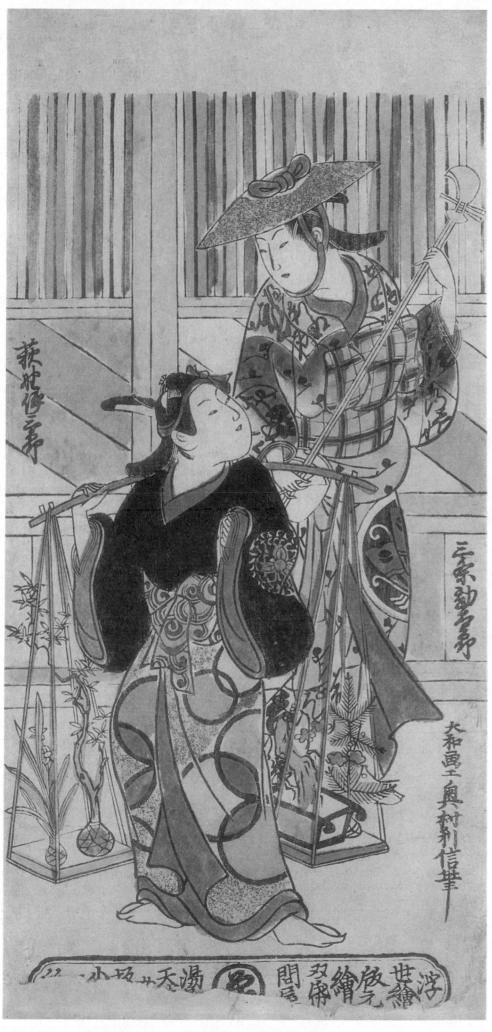

7. OKUMURA TOSHINOBU: *Actors as a flower-seller and a street musician*. About 1740.
London, British Museum

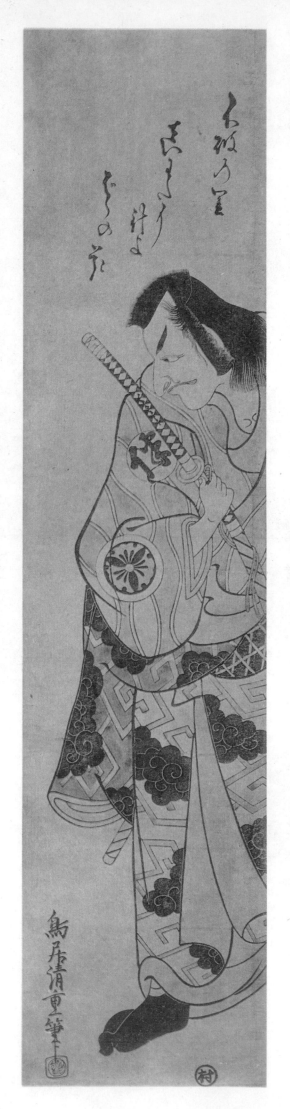

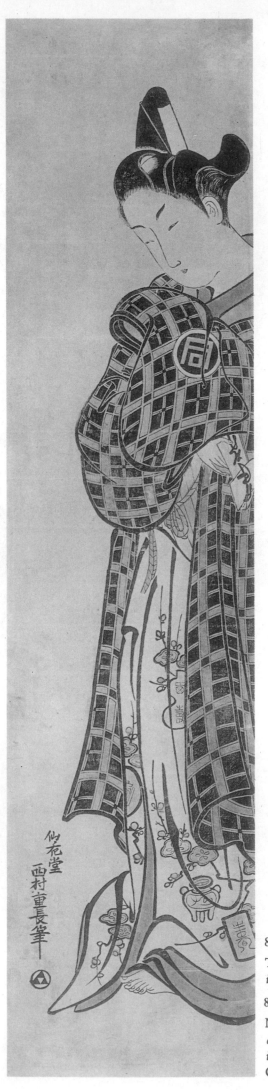

8a.

TORII KIYOSHIGE: *The actor Matsumoto Kos*
in character. About 1742. Chicago, Art Inst

8b.

NISHIMURA SHIGENAGA: *Sanogawa Ichimats*
an actor of outstanding popularity, as Hisama
in a play performed in 1743.
Chicago, Art Institute.

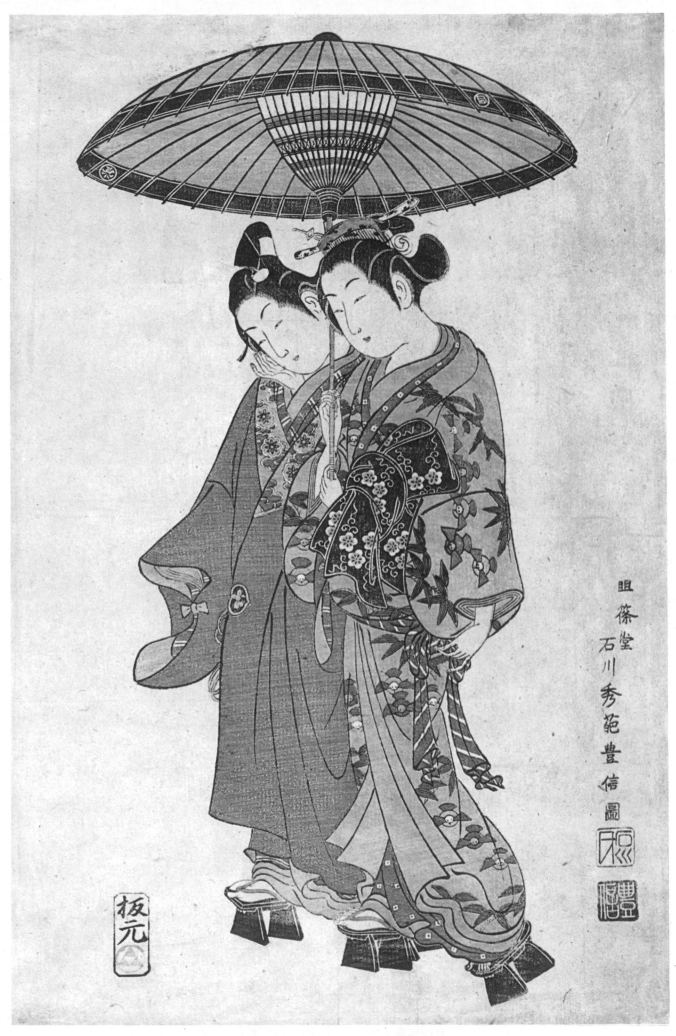

9. ISHIKAWA TOYONOBU: *Actors as lovers under one umbrella, in a play performed in 1747.*
Honolulu Academy of Arts, Hawaii, Michener Collection

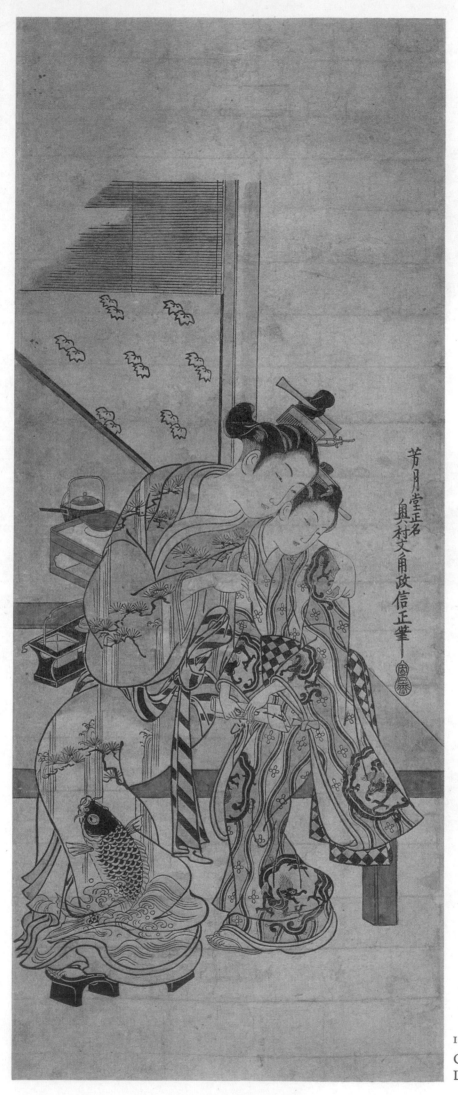

芳月堂正名
奥村文角政信正筆

10.

OKUMURA MASANOBU: *The love-letter*. About 1748.
London, British Museum

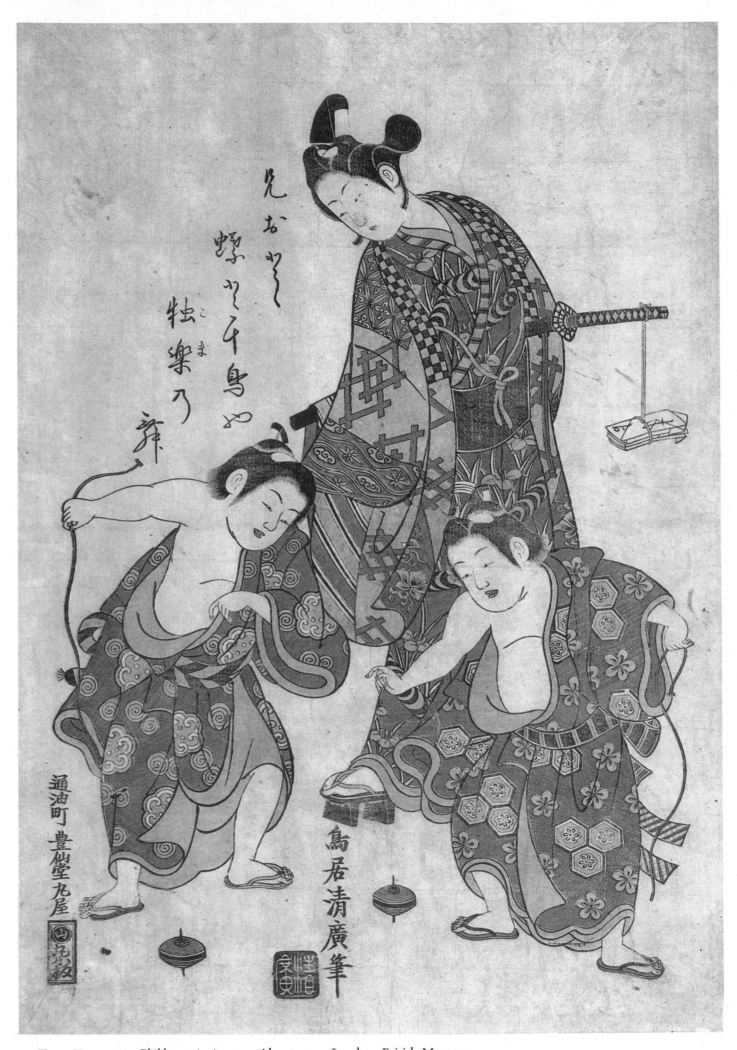

11. TORII KIYOHIRO: *Children spinning tops.* About 1745. London, British Museum

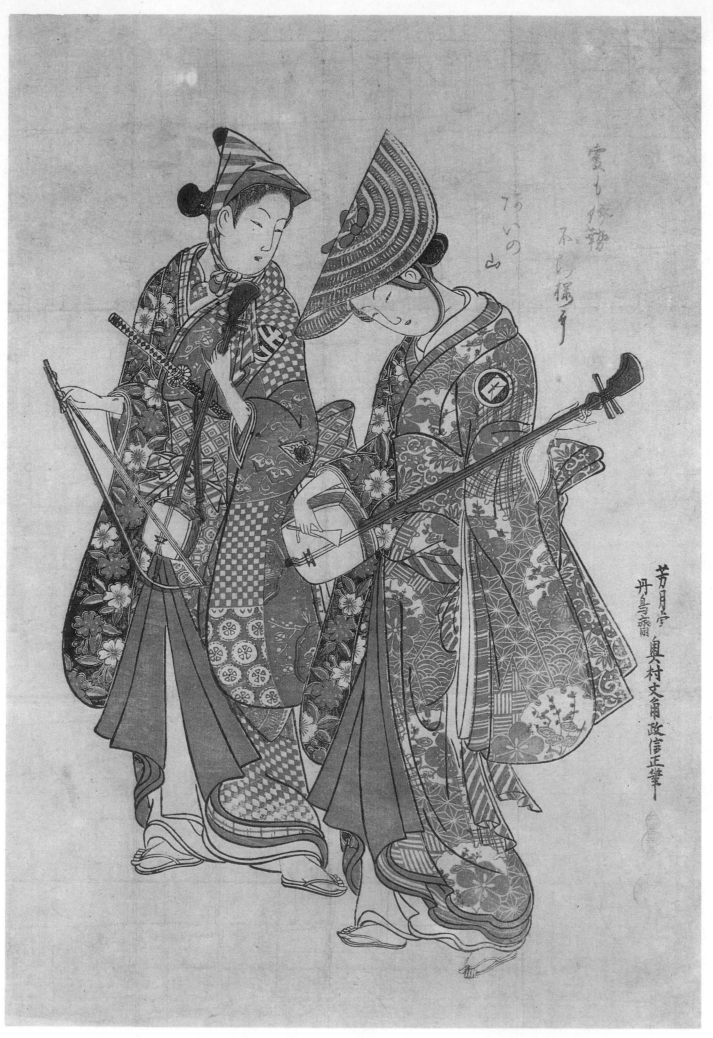

12. OKUMURA MASANOBU: *Actors as the ill-starred lovers, the incendiarist Yaoya O'shichi and Kichisaburo, in a play performed in* 1750.
Boston, Museum of Fine Arts, William S. and John T. Spaulding Collection

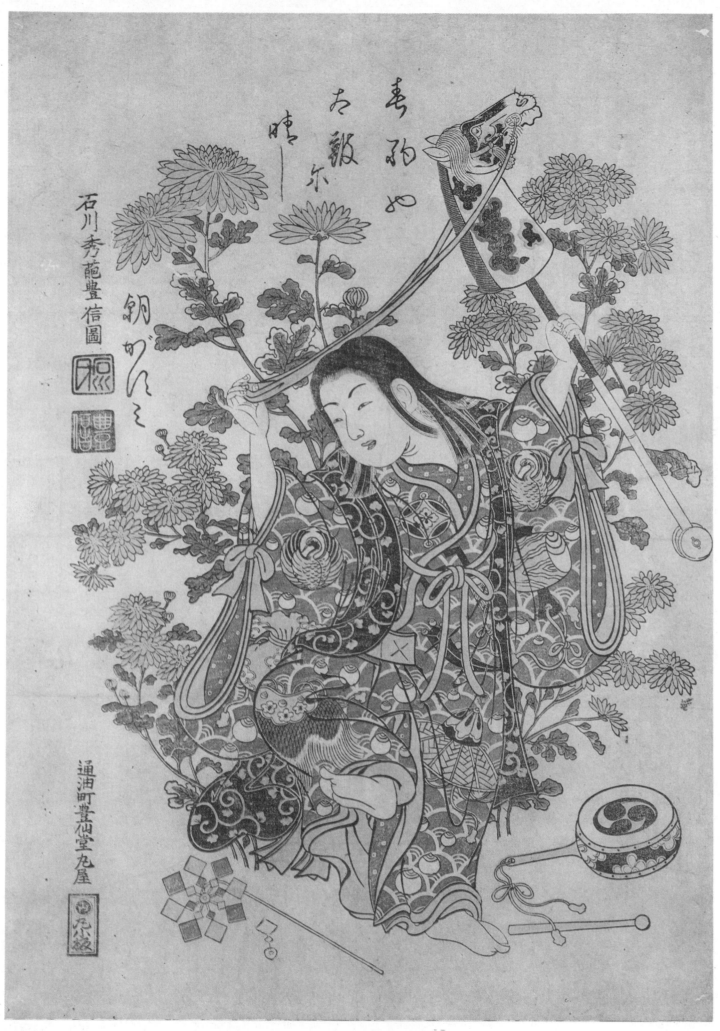

13. ISHIKAWA TOYONOBU: *Boy dancing with a hobby-horse.* About 1755. London, British Museum

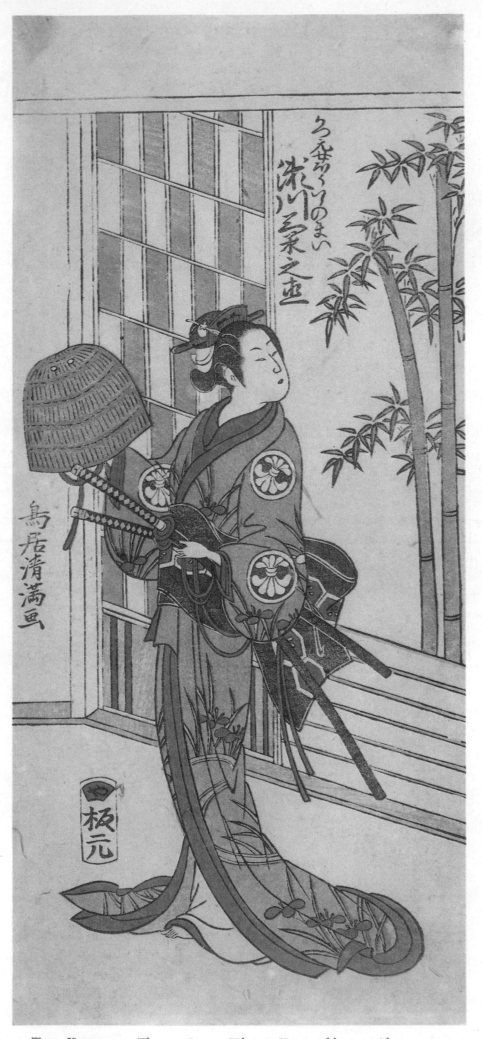

14. **Torii Kiyomitsu**: *The actor Segawa Kikunojo II as a girl komuso*. About 1762-1763. Private Collection.

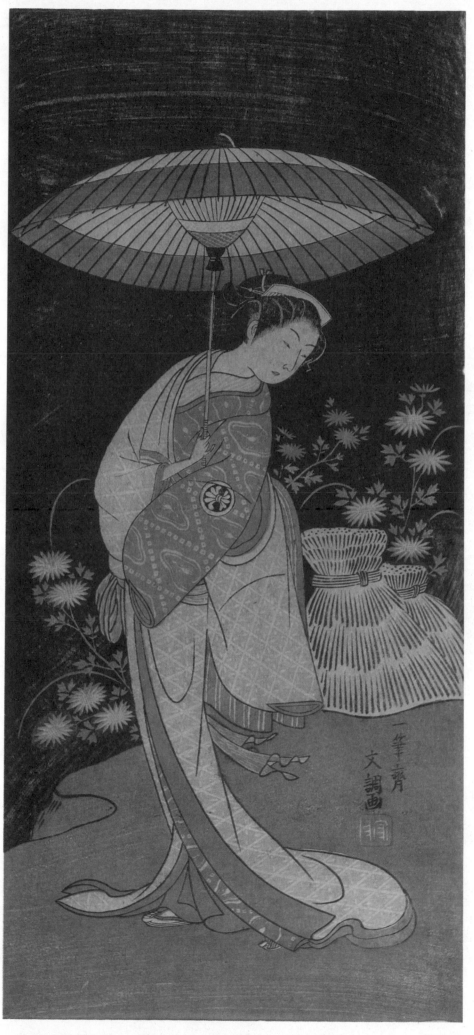

15. IPPITSUSAI BUNCHO: *The actor Segawa Kikunojo II as O'hatsu in a play performed in 1767.* London, British Museum

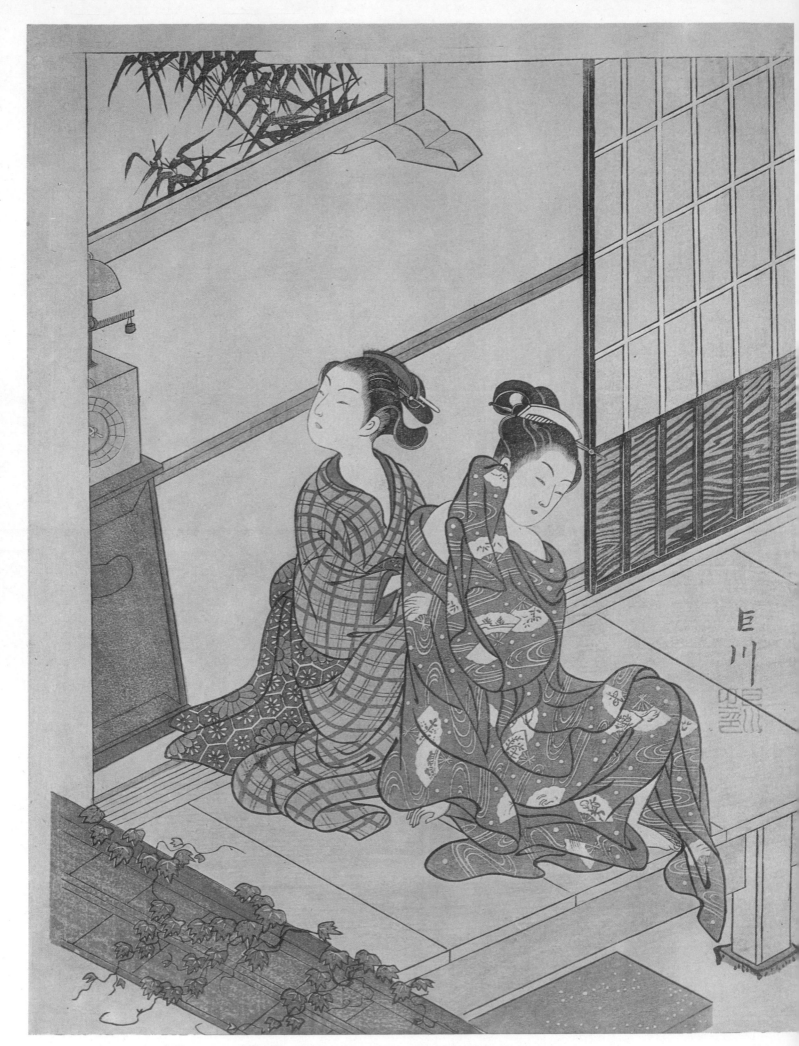

16. SUZUKI HARUNOBU: '*The Evening Bell of the Clock*'. About 1766. Chicago, Art Institute

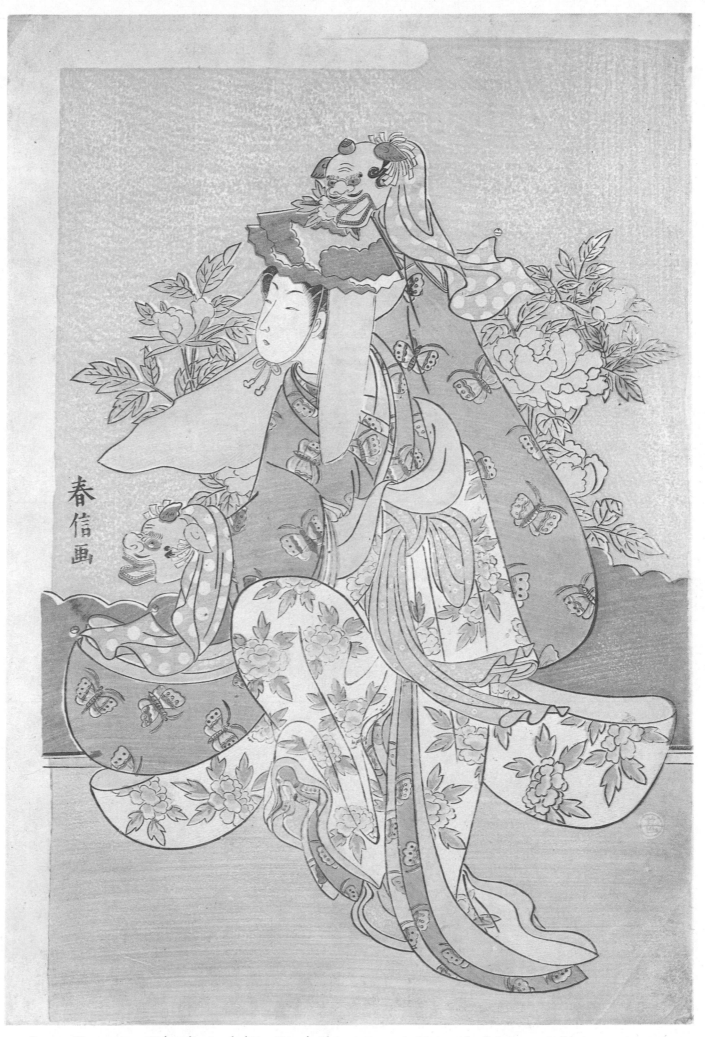

17. SUZUKI HARUNOBU: *Girl performing the 'Lion Dance'*. About 1769–1770. Mannendorf, Amstutz Collection

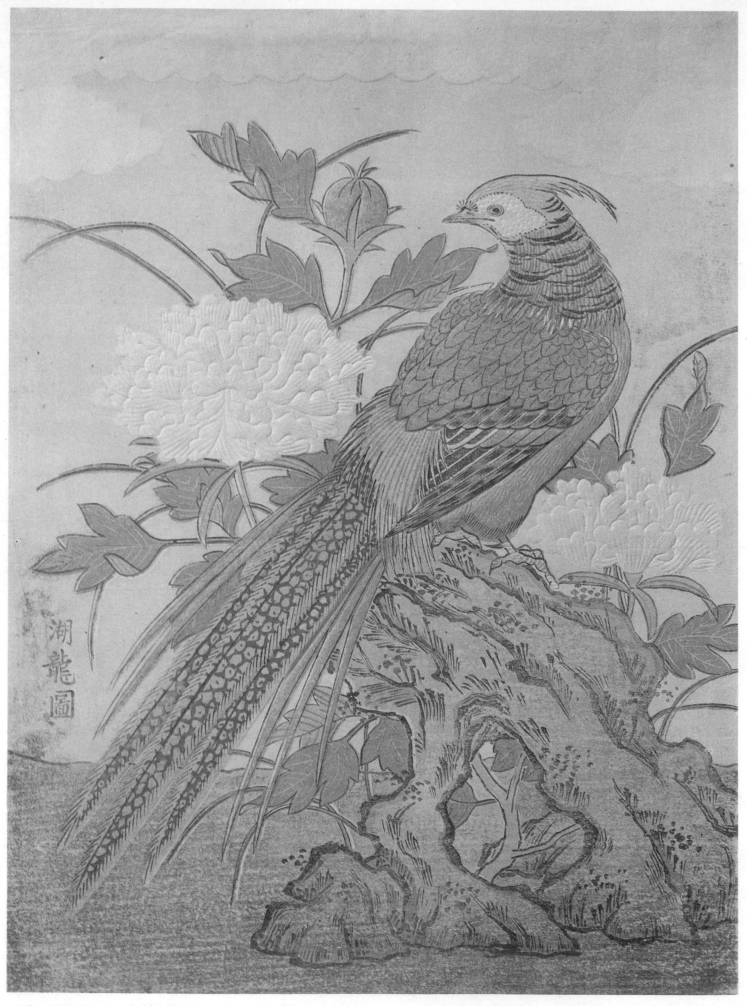

18. ISODA KORYUSAI: *Golden pheasant and peonies.* About 1769–1770. Lausanne, Riese Collection

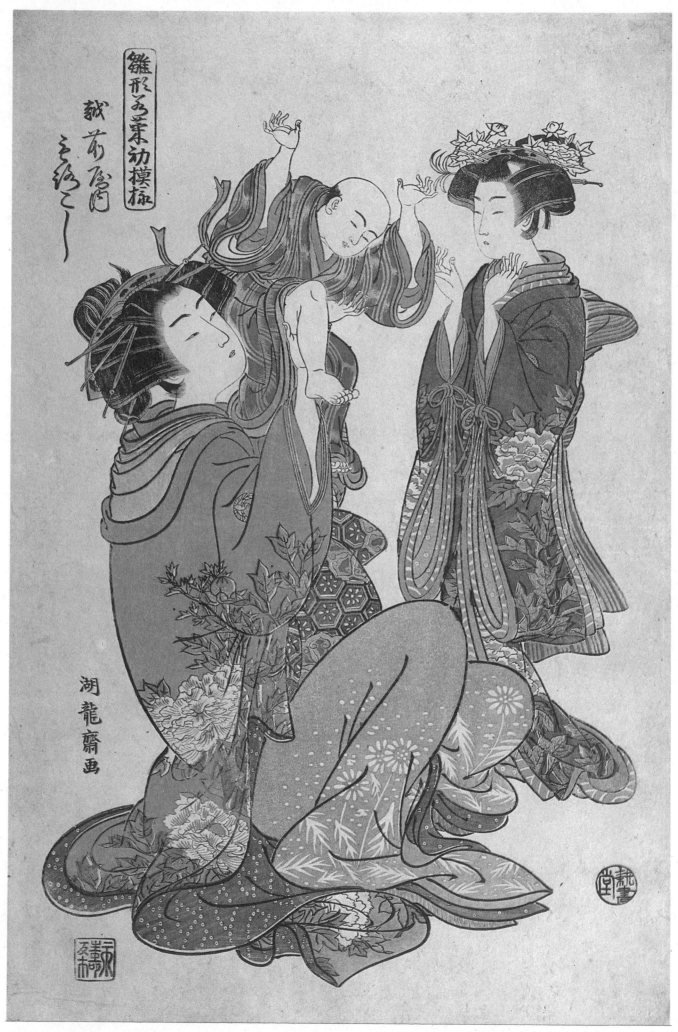

19. ISODA KORYUSAI: *The courtesan Morokoshi of Echizen-ya with her child, attendant standing by.* About 1776-1777. London, British Museum

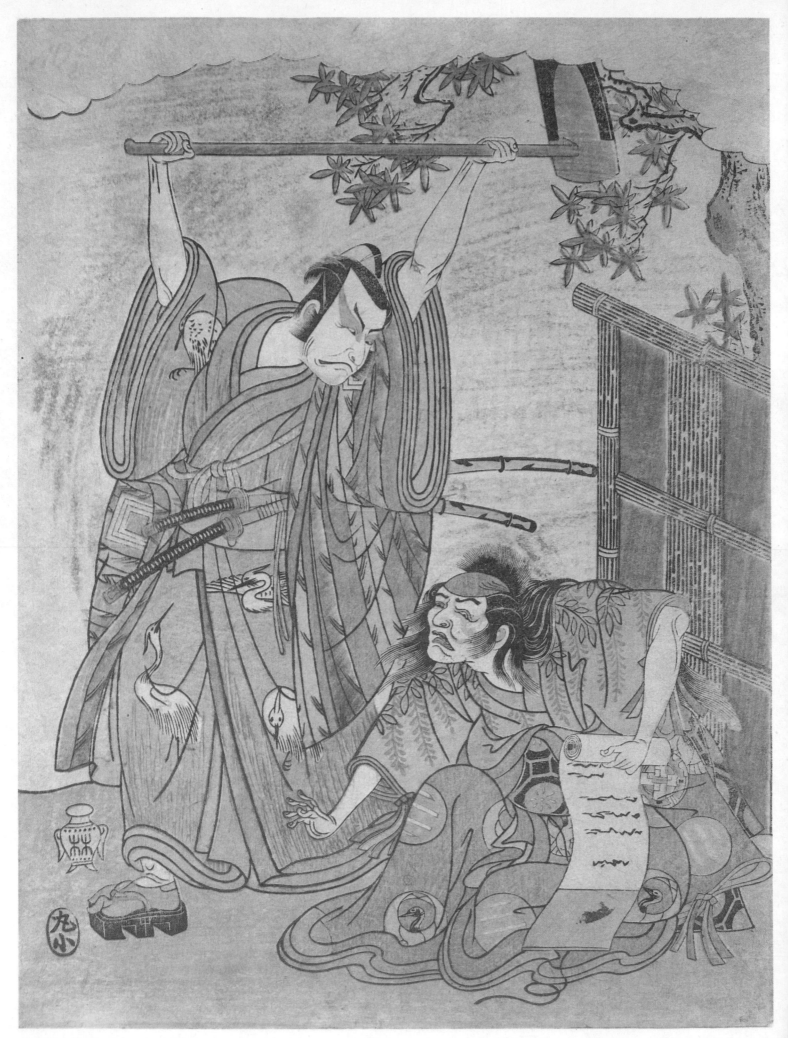

20. KATSUKAWA SHUNSHO: *The actors Ichikawa Danjuro IV and Nakamura Utaemon in a theatrical duo*. 1769. Münster, Scheiwe Collection

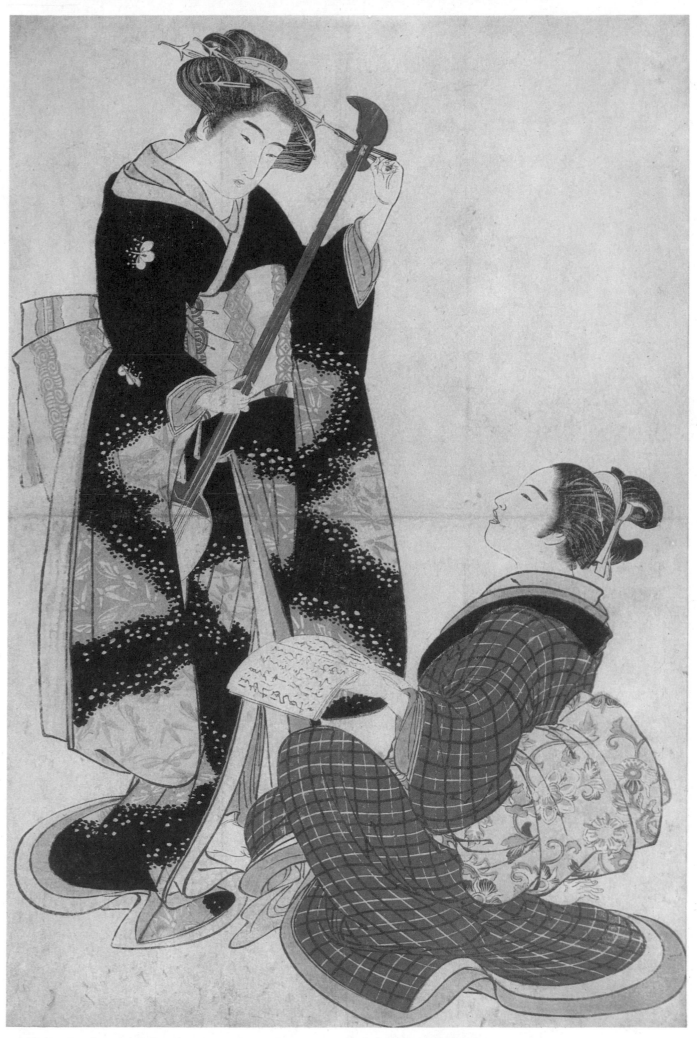

21. KITAO SHIGEMASA: *Rehearsing a new song*. About 1777. London, British Museum

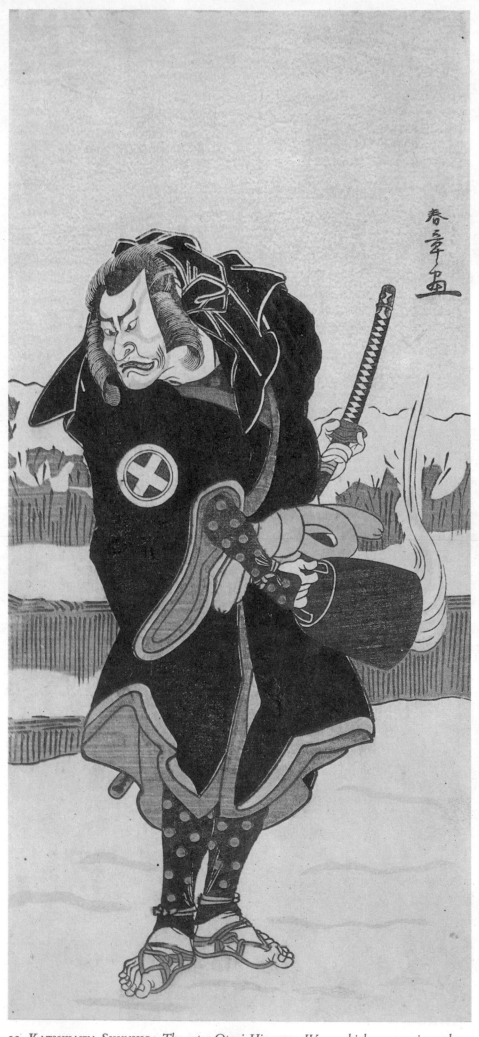

22. **KATSUKAWA SHUNSHO:** *The actor Otani Hiroemon IV as a highwayman in a play performed in* 1777. Mound, Minnesota, Gale Collection

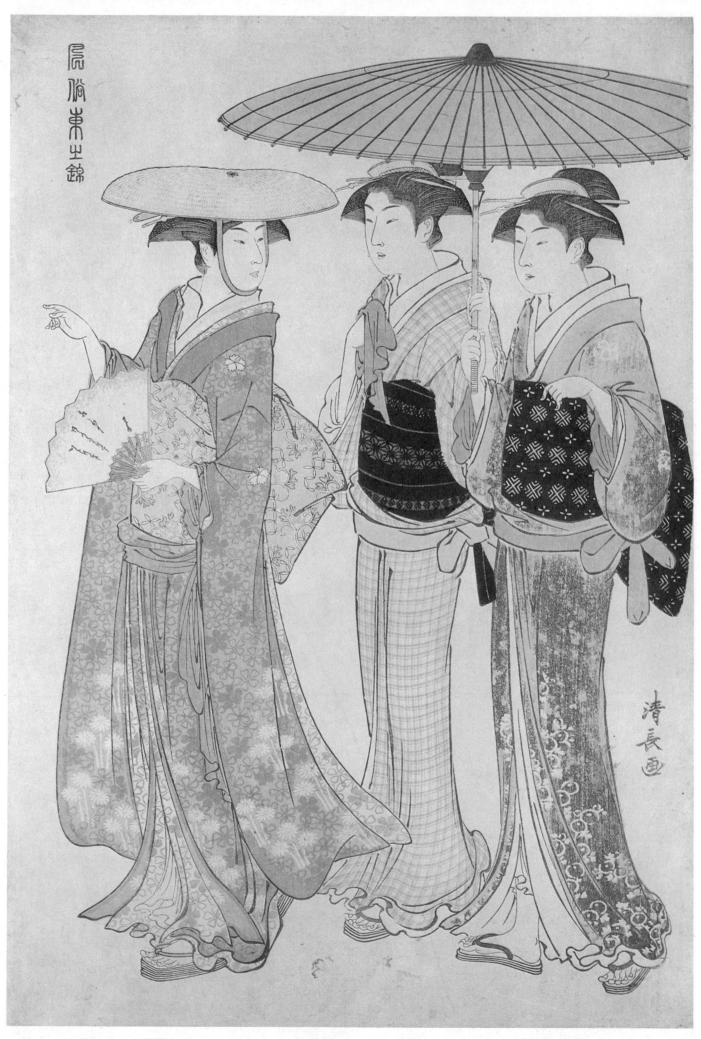

23. Torii Kiyonaga: *A lady with two servants*. 1783. Boston, Museum of Fine Arts, Bigelow Collection

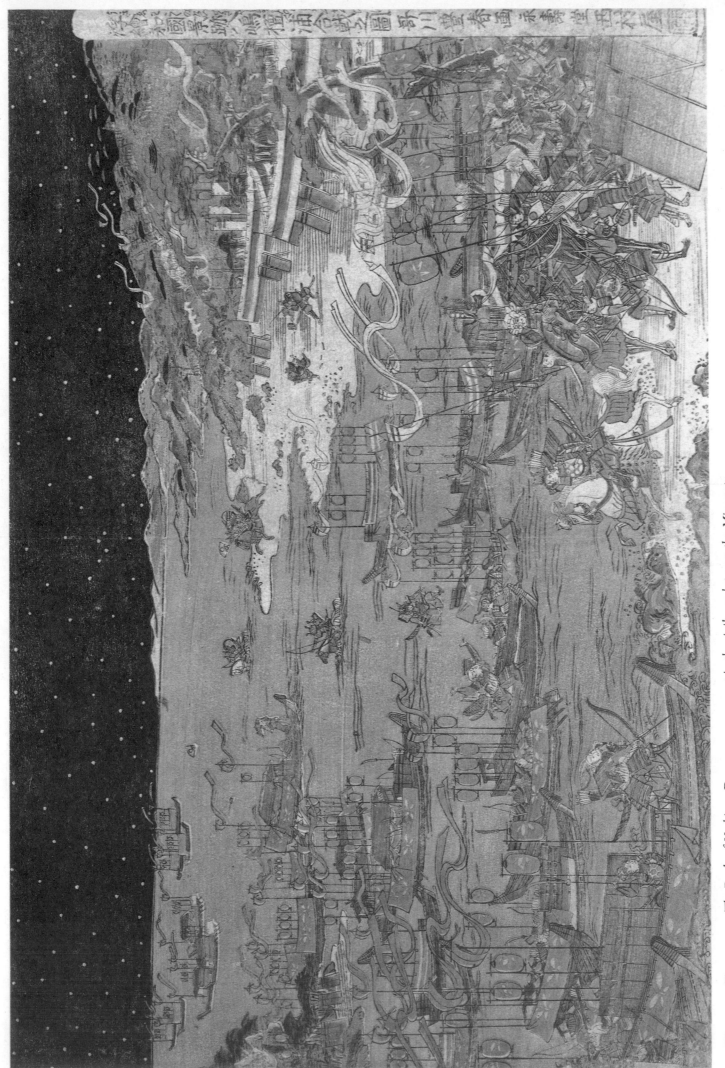

24. UTAGAWA TOYOHARU: *The Battle of Yashima, Dan-no-ura, an event in the civil war between the Minamoto and Taira clans. About 1775–1780.* London, British Museum.

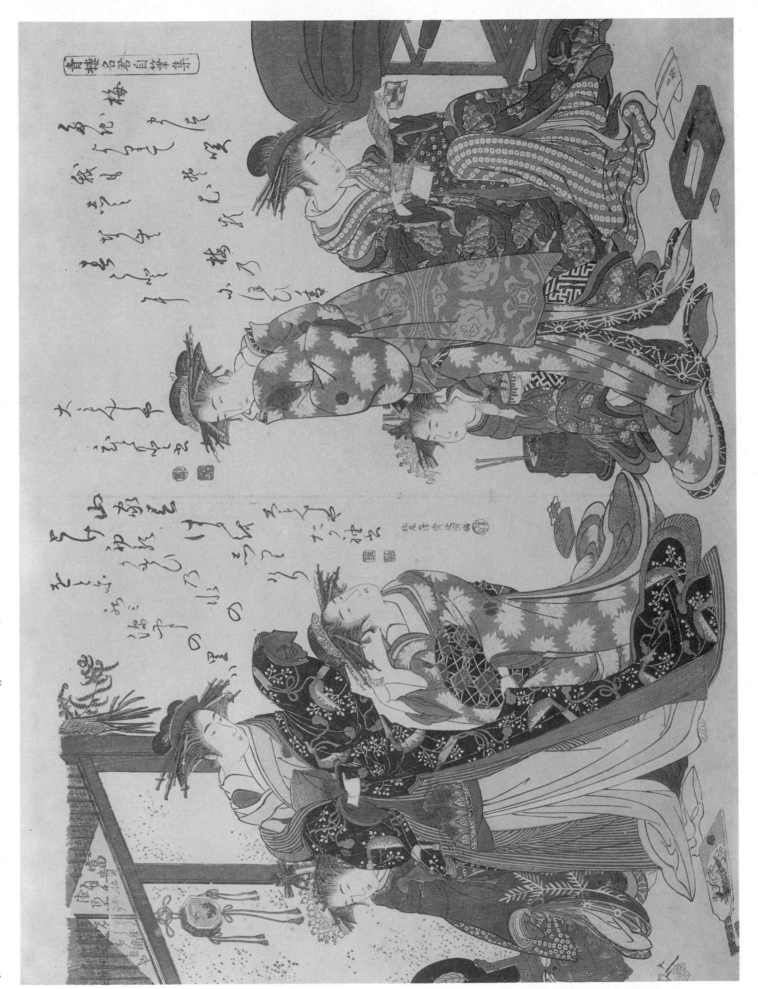

25. Kitao Masanobu: *The courtesans Hitomoto and Tagosode.* 1783. Author's Collection.

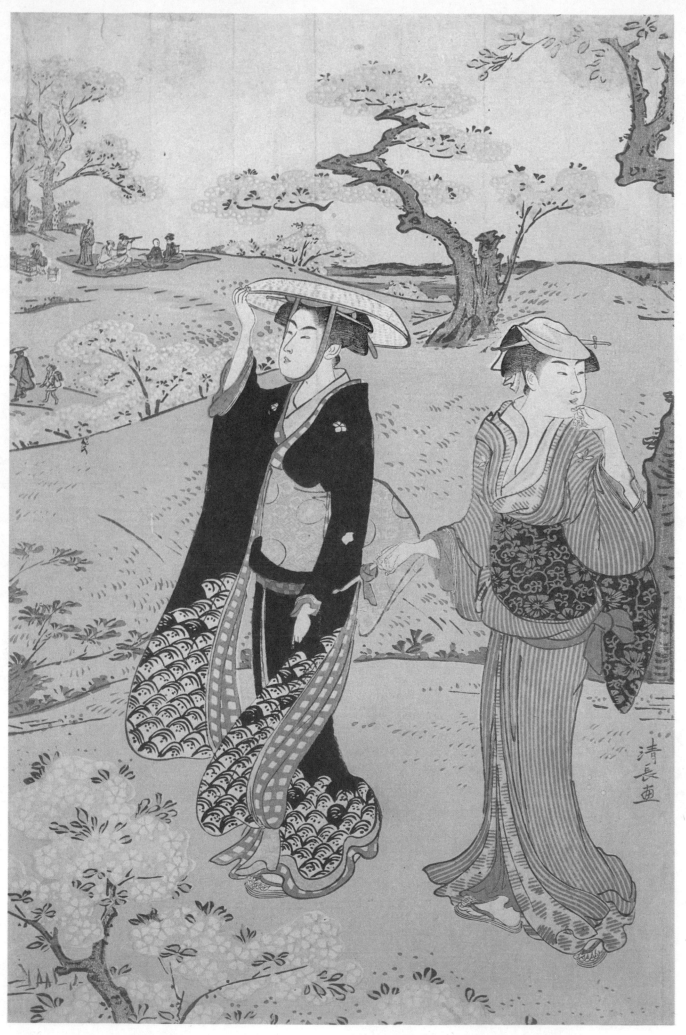

26. TORII KIYONAGA: *Cherry-blossom at Asakayama near Edo*. About 1787-1788. London, British Museum

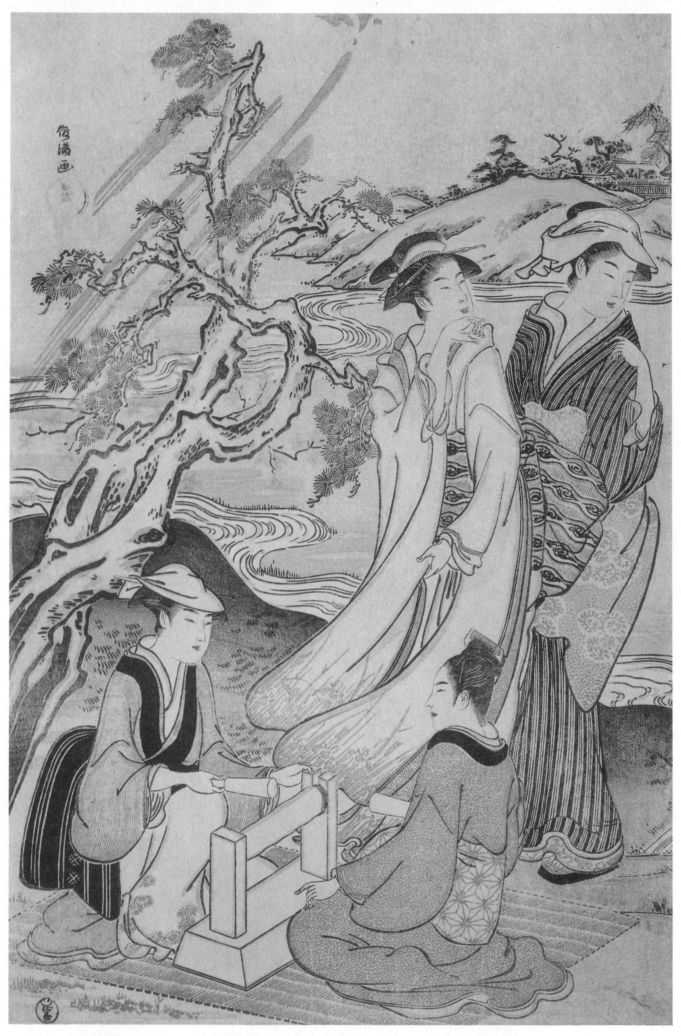

27. KUBO SHUNMAN: *The Toi, one of the 'Six Jewel Rivers'*. About 1787. London, British Museum

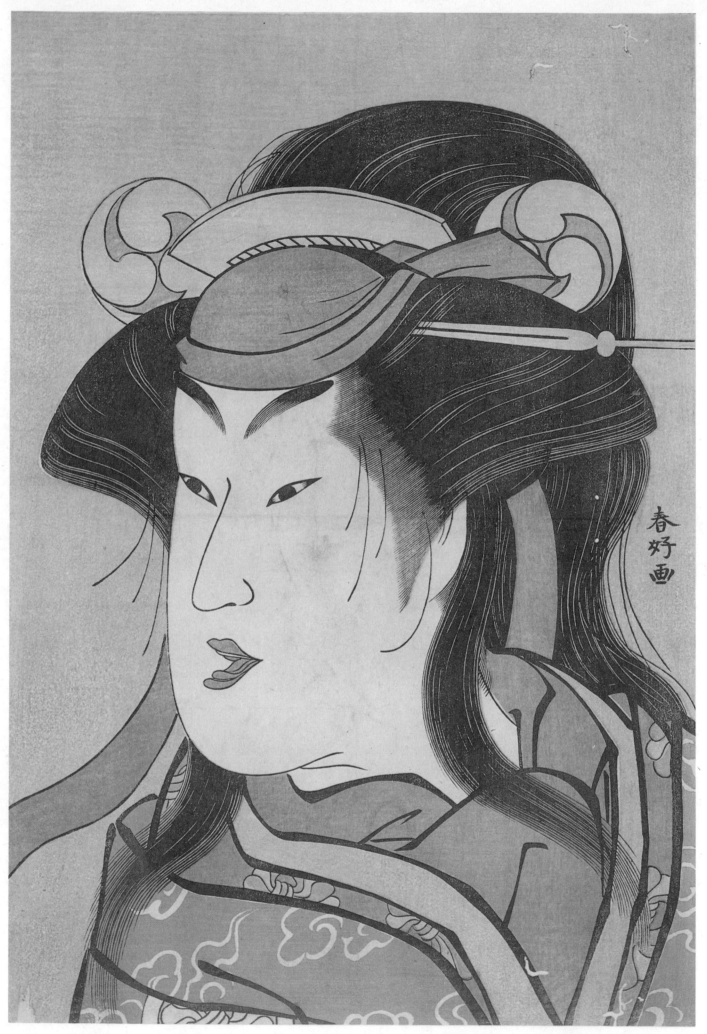

28. KATSUKAWA SHUNKO: *Head of a male actor taking a female part.* About 1787-1788. Mannendorf, Amstutz Collection

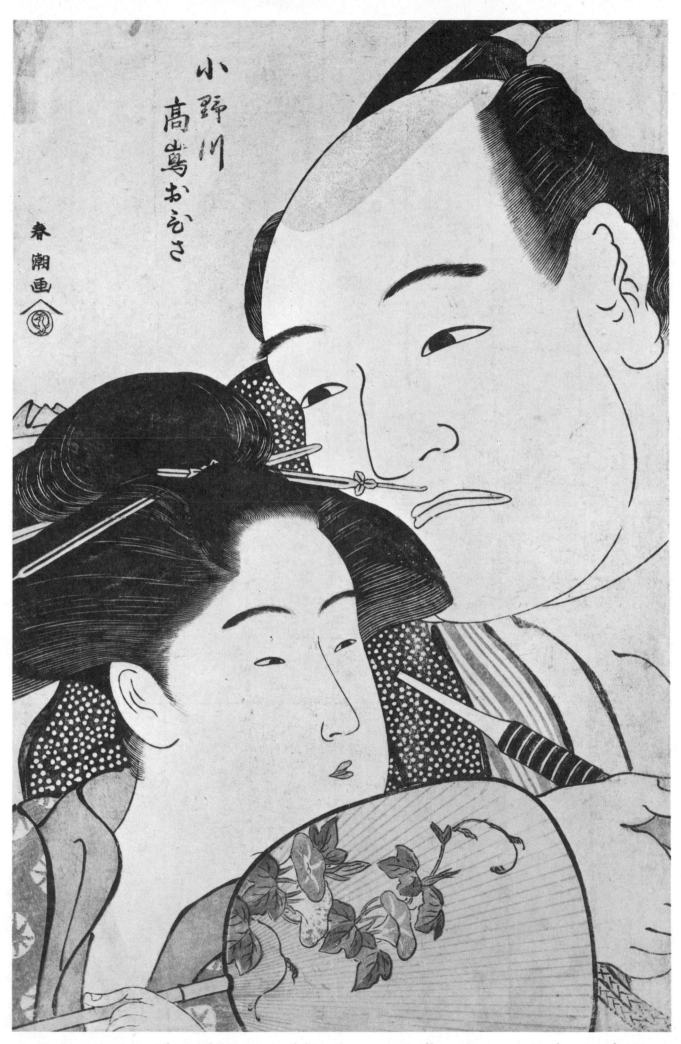

小野川
高嶋お久さ

春潮画

29. YUSHIDO SHUNCHO: *The wrestler Onogawa and the tea-house waitress O'hisa.* About 1792. London, British Museum

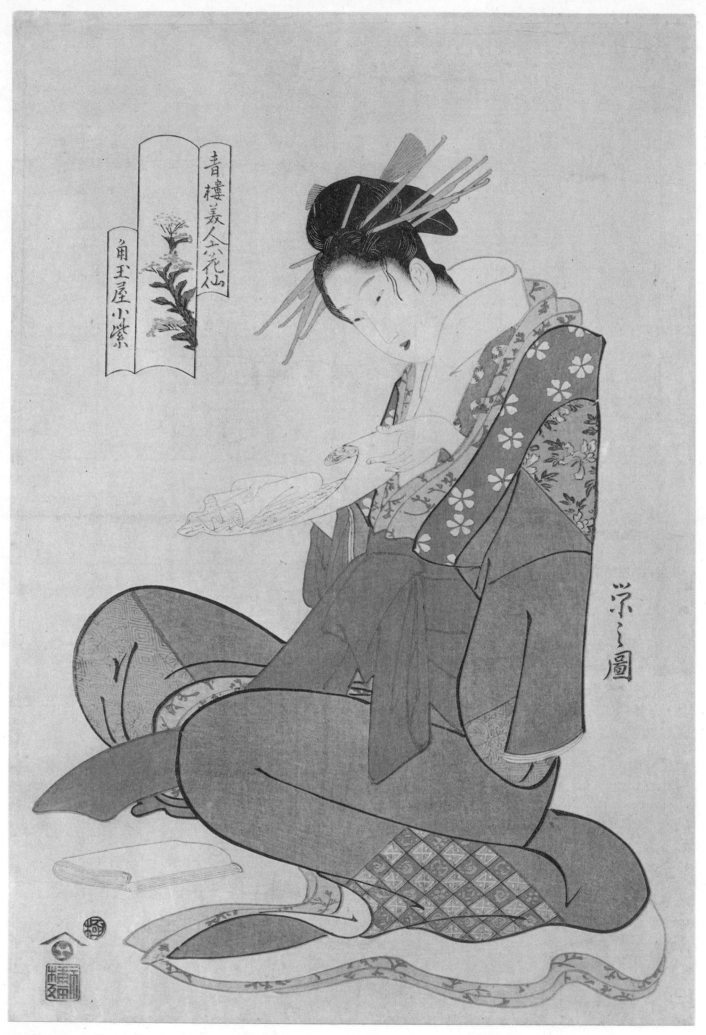

青
楼
美
人
六
花
仙

角
玉
屋
小
紫

30. CHOBUNSAI EISHI: *Komurasaki sitting on her heels.* About 1794-1795. Chicago, Art Institute

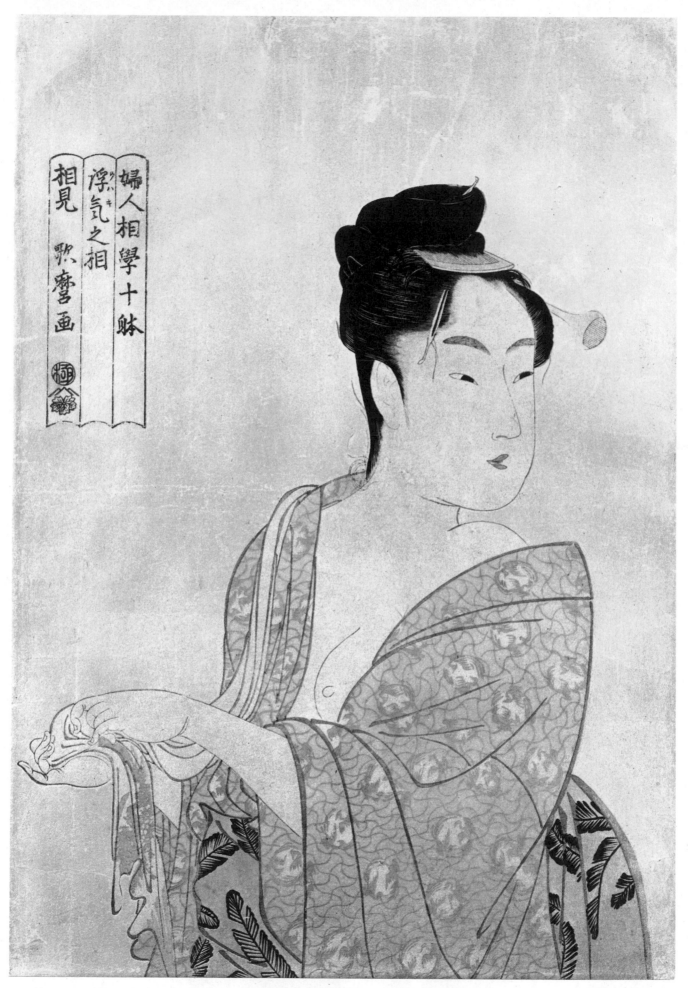

婦人相學十躰
浮気之相
相見
歌麿画

31. KITAGAWA UTAMARO: 'The Passionate Type'. About 1792-1793. London, British Museum

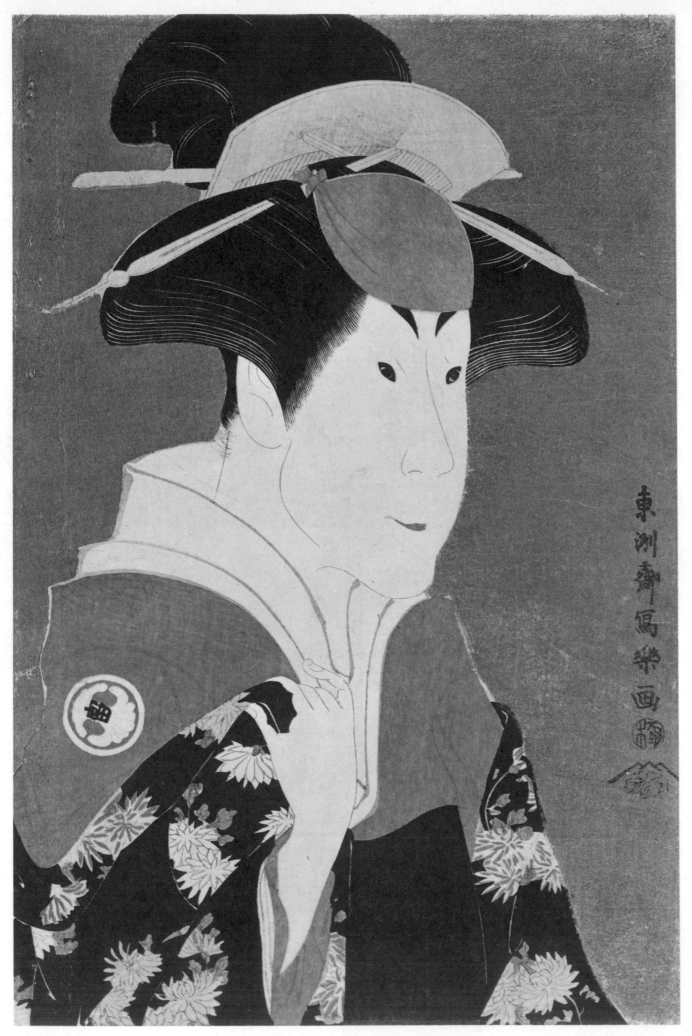

東洲斎写楽画

32. Toshusai Sharaku: *The actor Segawa Tomisaburo as Yadorigi in a play performed in* 1794. London, British Museum

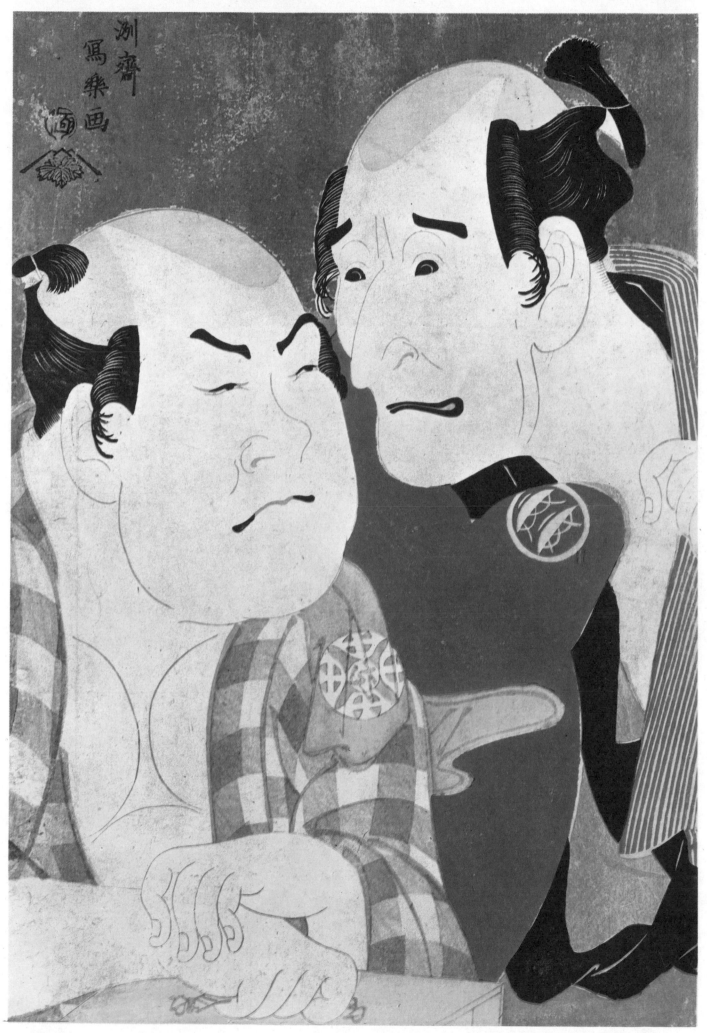

33. TOSHUSAI SHARAKU: *The actors Nakamura Konozo and Nakajima Wadaemon in character.* 1794. London, British Museum

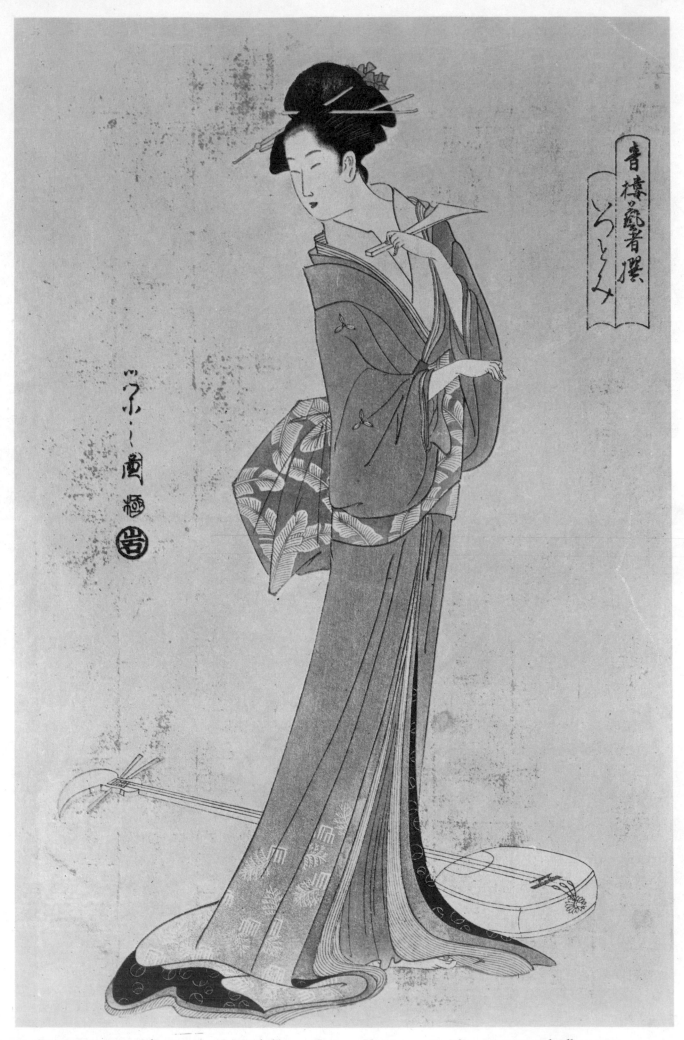

34. **CHOBUNSAI EISHI:** *The courtesan Itsutomi holding a plectrum.* About 1794. London, Victoria and Albert Museum

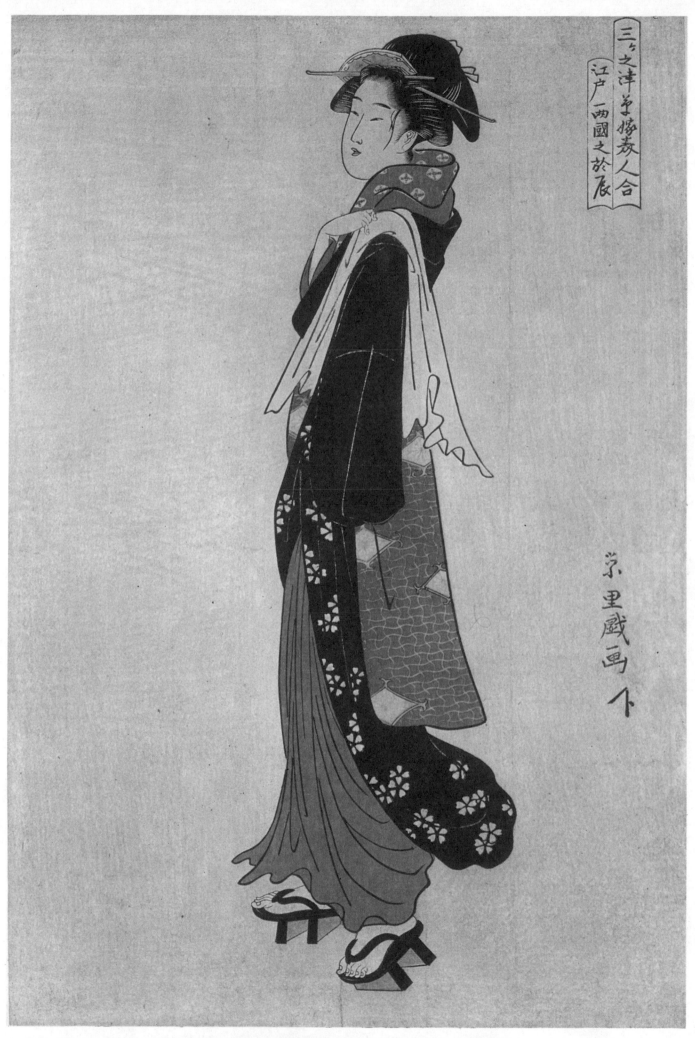

三ッ之津筆懐姿人合
江戸一両國之於辰

栄里戯画
下

35. EIRI: *Woman walking with a towel over her shoulder.* About 1795. Paris, Musée Guimet

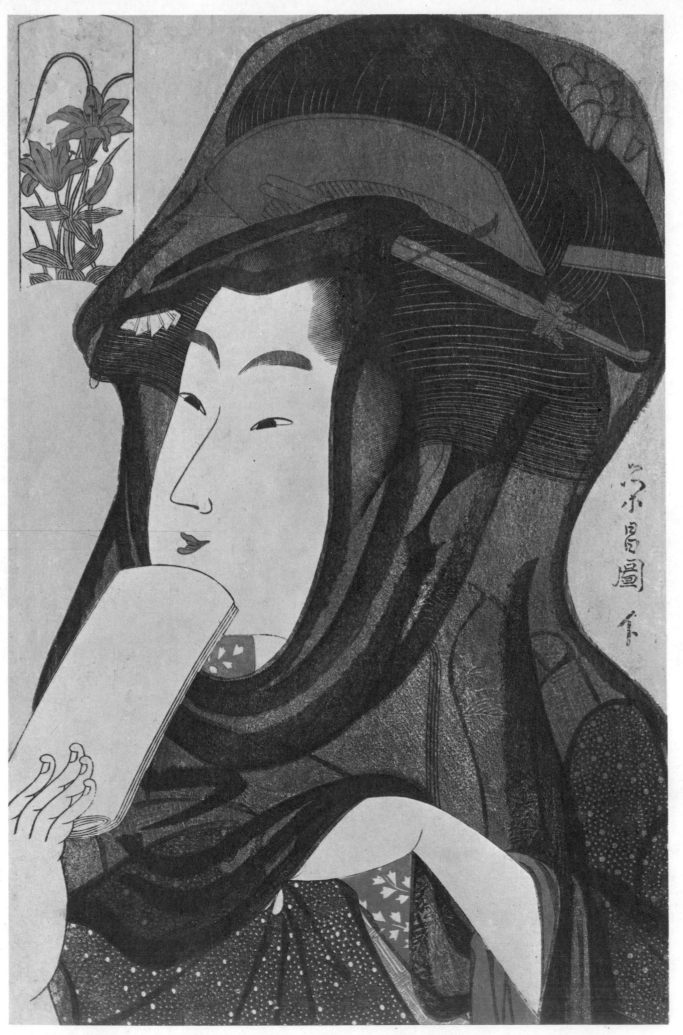

36. CHOKOSAI EISHO: *Head of a girl in a transparent hood.* About 1795-1796. San Francisco, Grabhorn Collection

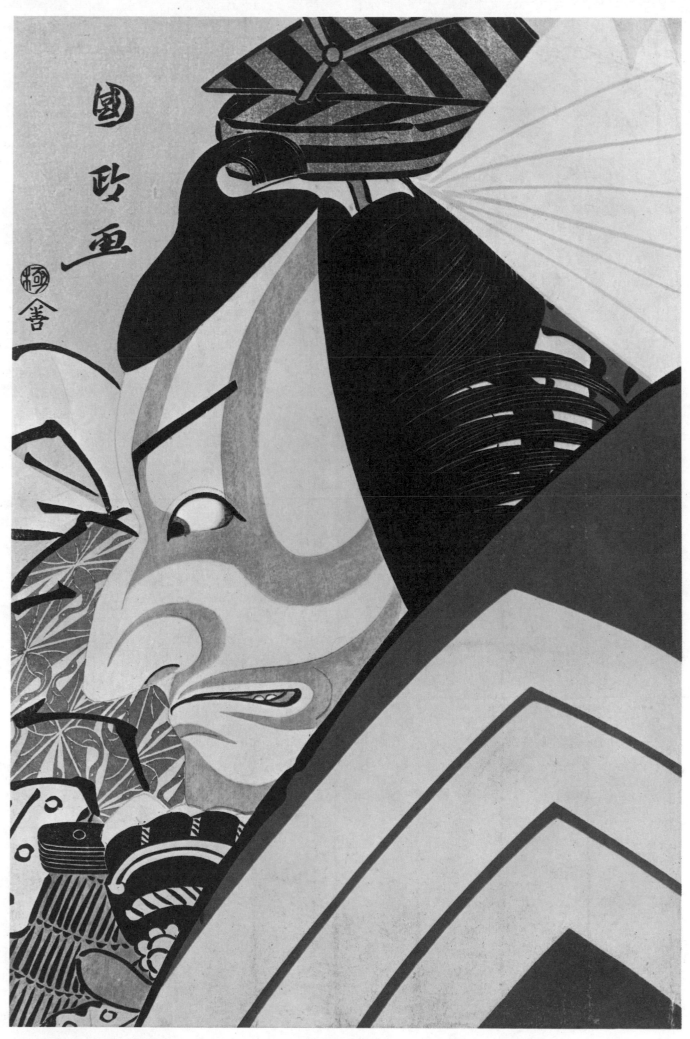

37. **UTAGAWA KUNIMASA:** *The actor Ichikawa Ebizo in the Shibaraku episode in a play performed in 1796.*
London, British Museum

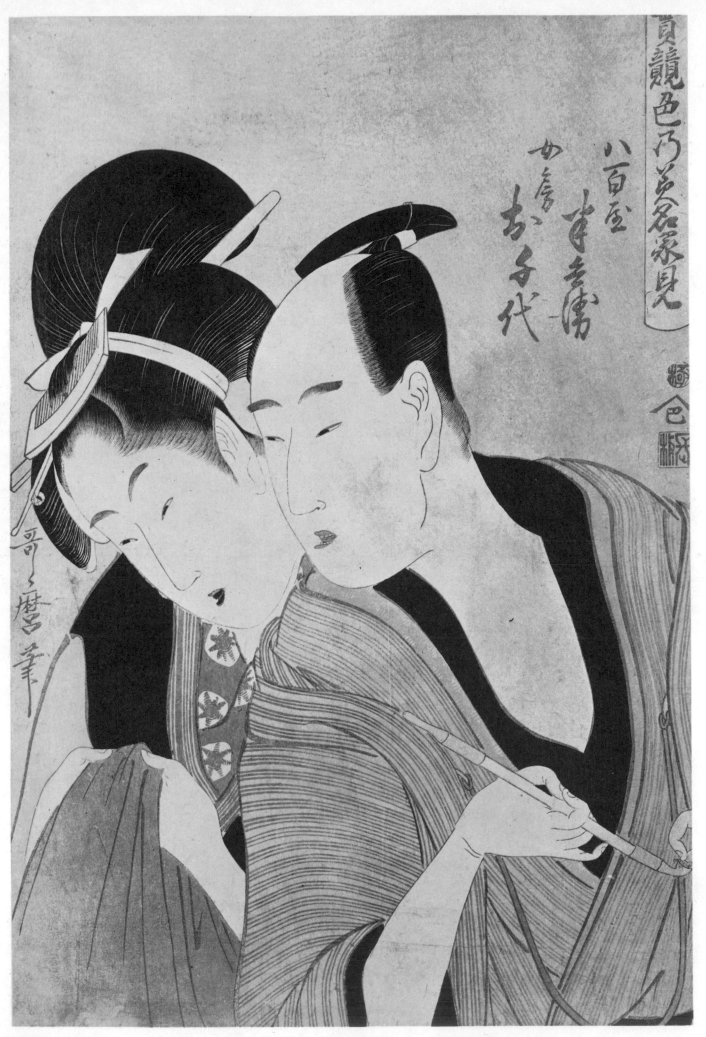

顔競色乃名家見

八百屋

女房

お千代

中吉滞

38. KITAGAWA UTAMARO: *The lovers Hambei and O'chie.* 1797-1798. London, British Museum

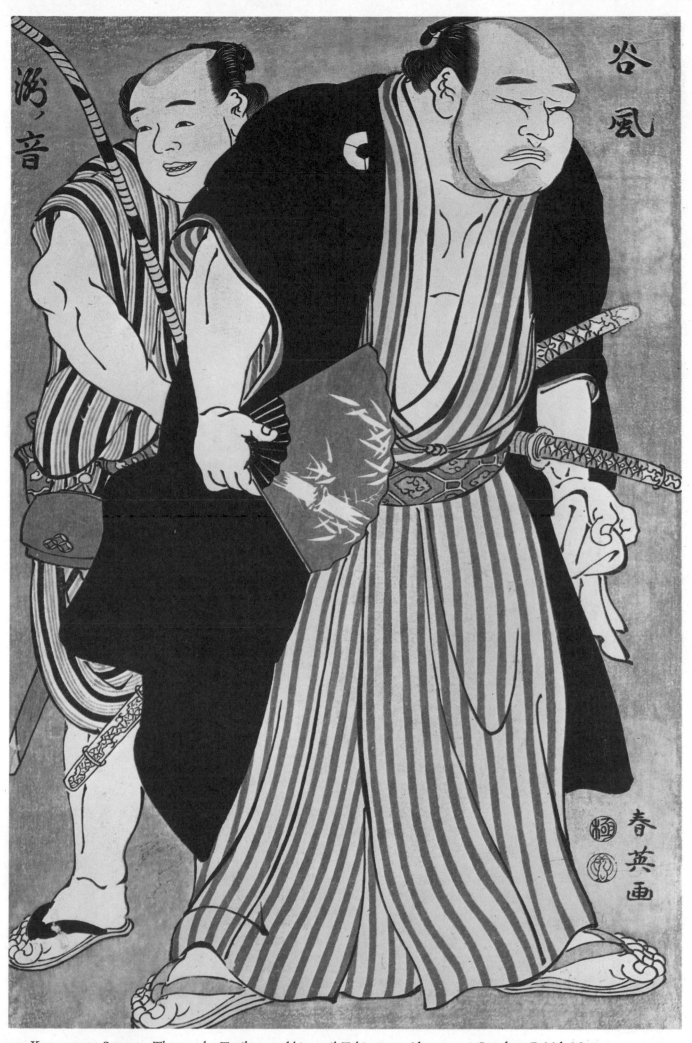

瀧ノ音

春英画

39. KATSUKAWA SHUNEI: *The wrestler Tanikaze and his pupil Taki-no-oto*. About 1796. London, British Museum

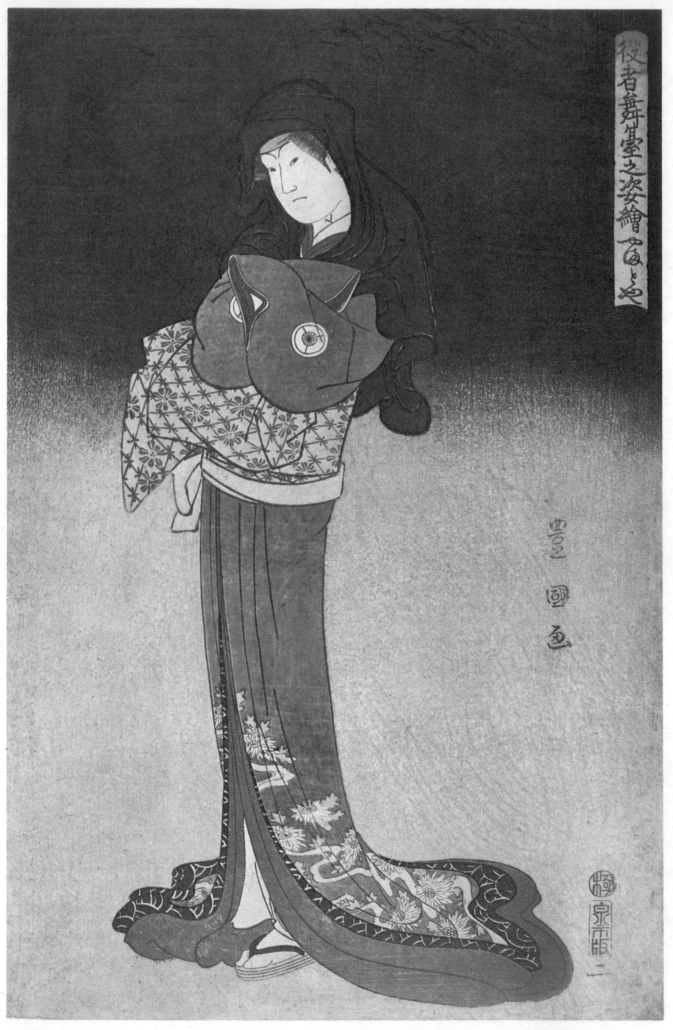

役者舞臺之姿繪内与さ

豊國画

40. UTAGAWA TOYOKUNI: *The actor Iwai Hanshiro in a feminine role, in a play performed in 1795.* Honolulu Academy of Arts, Hawaii, C. Montague Cooke Jr. Memorial Collection

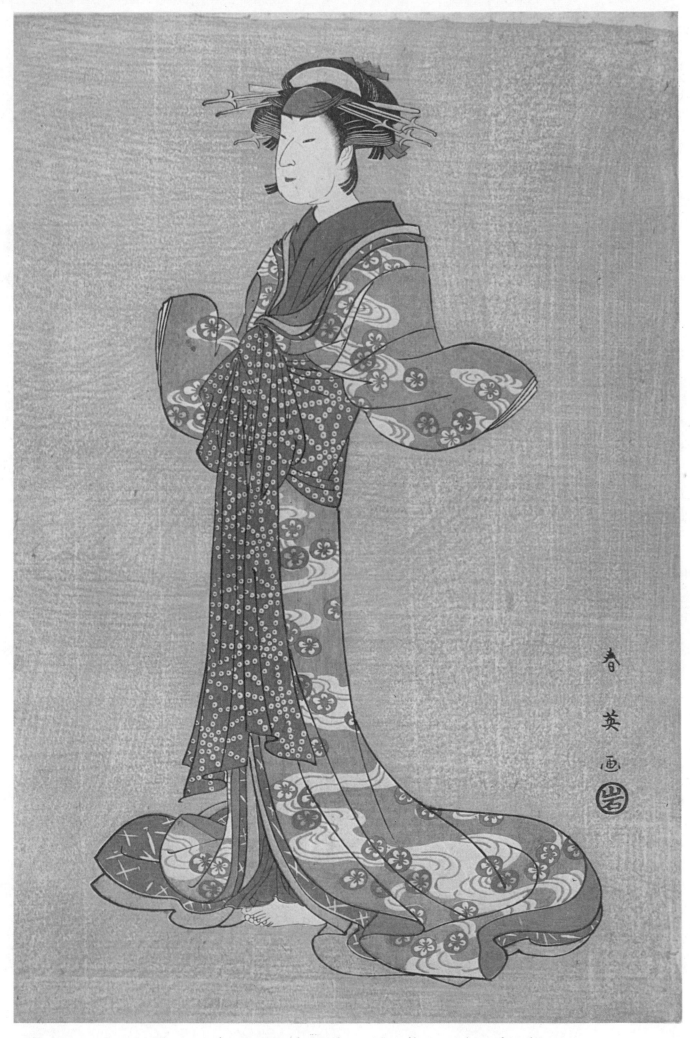

41. KATSUKAWA SHUNEI: *The actor Nakayama Tomisaburo as the courtesan O'karu in a play performed in 1795.*
Honolulu Academy of Arts, Hawaii, Michener Collection

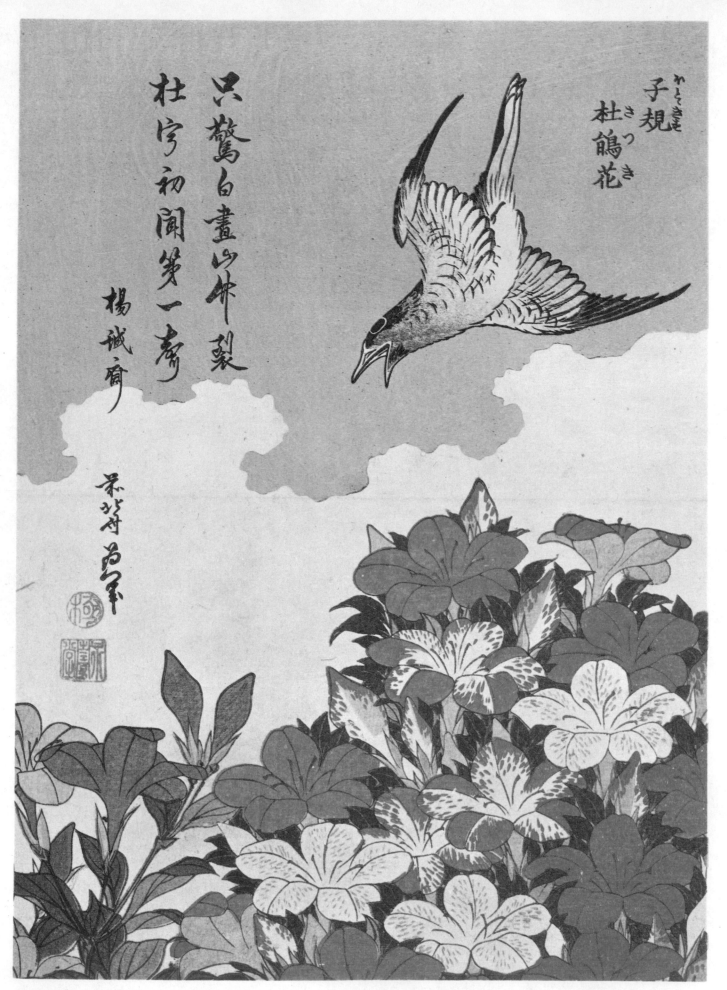

42. KATSUSHIKA HOKUSAI: *Cuckoo and azalea*. About 1828. London, British Museum

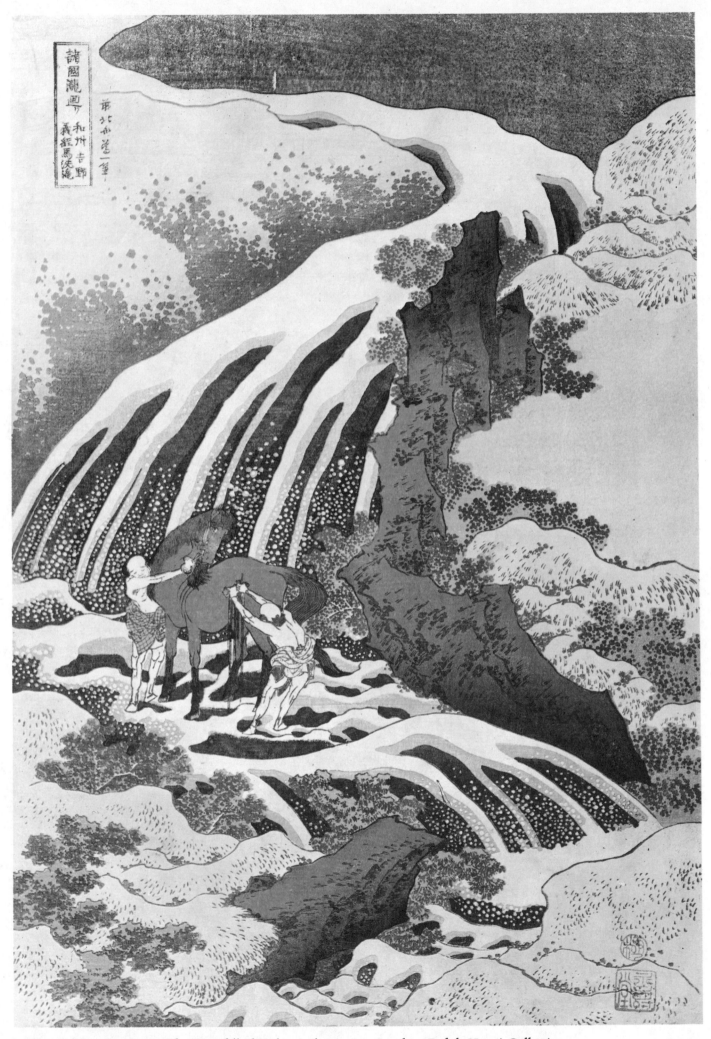

43. KATSUSHIKA HOKUSAI: *The Waterfall of Yoshino*. About 1830. London, Ralph Harari Collection

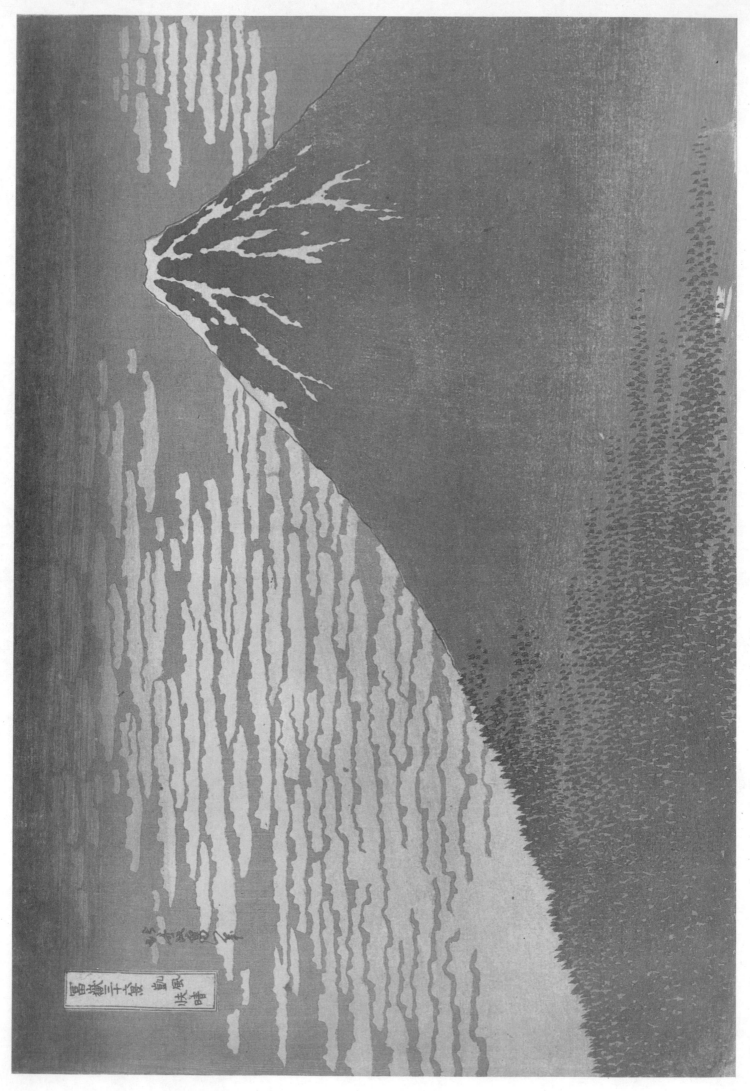

44. Katsushika Hokusai: *Fuji in clear weather.* About 1823–1829. London, British Museum

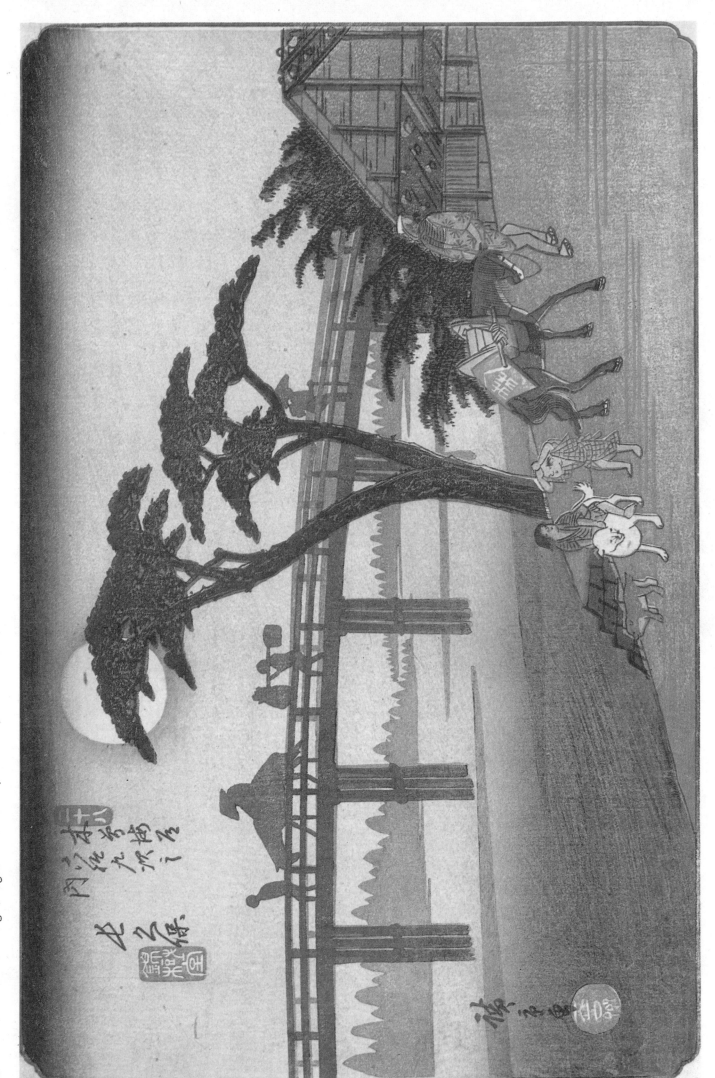

45. ANDO HIROSHIGE: *Moonlight, Nagakubo*. About 1840. London, British Museum

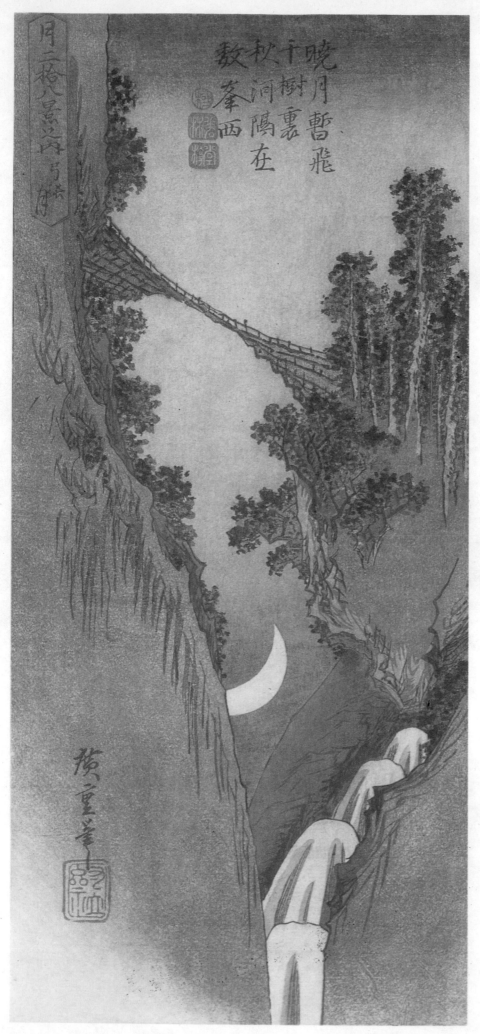

46. ANDO HIROSHIGE: *The Bow Moon*. About 1830–1835. Private Collection

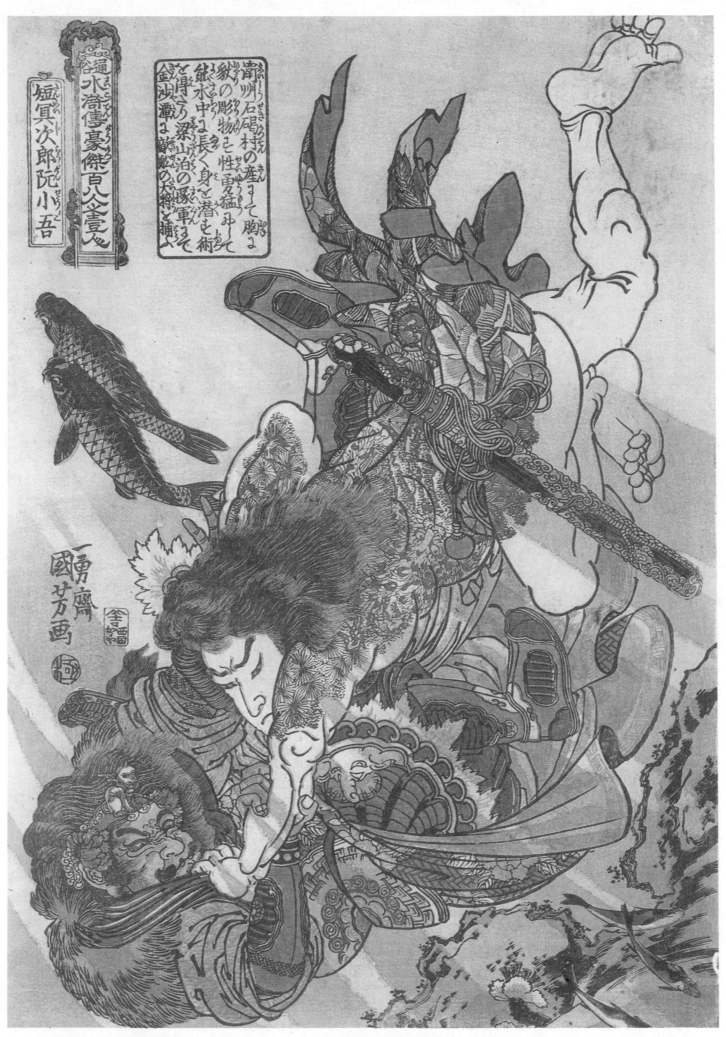

47. UTAGAWA KUNIYOSHI: *Tameijiro dan Shogo, one of the 108 Heroes of the Suikoden, grappling with an adversary under water.*
1827–1830. London, B. W. Robinson Collection

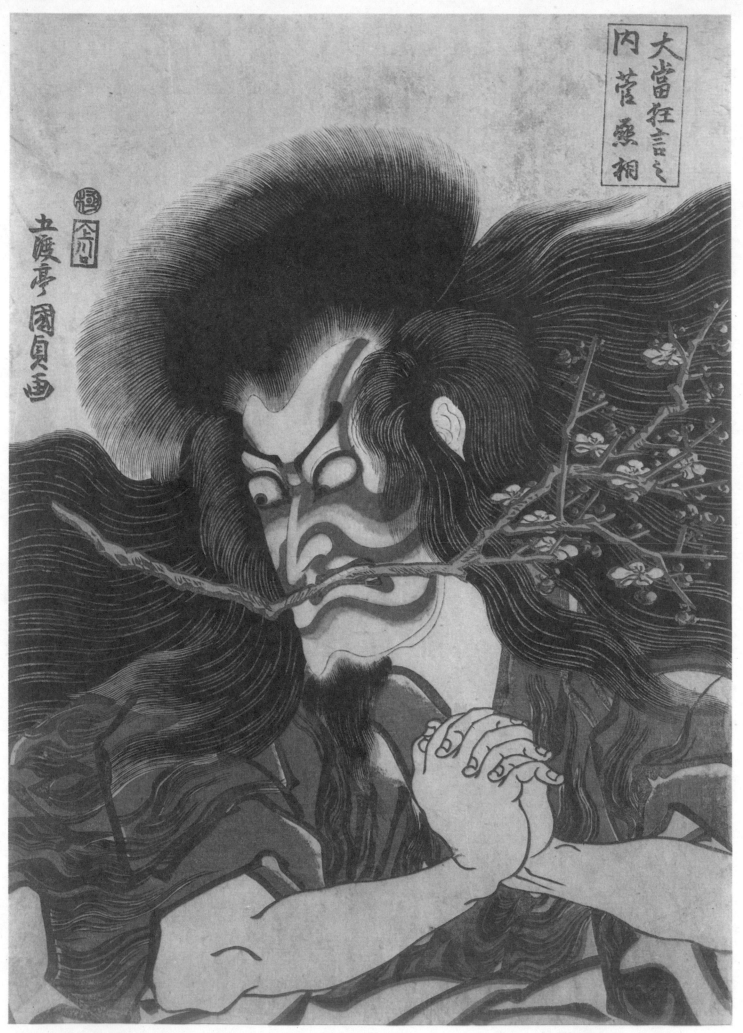

48. **UTAGAWA KUNISADA**: *The actor Ichikawa Danjuro VII in character*. About 1820. Paris, Janette Ostier Collection